MW00606300

Along
Massachusetts's
Historic Route 20

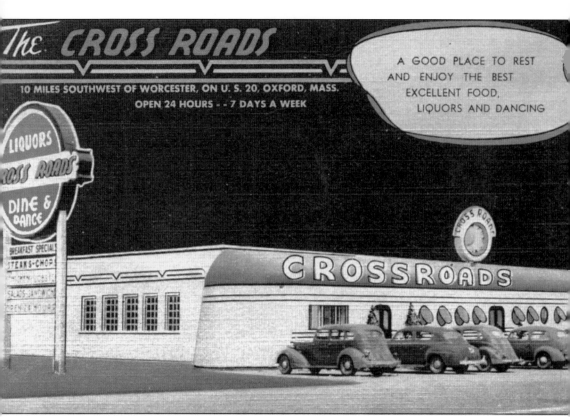

DUD'S GAS STATION ON GREENWATER POND. *"If you've got the money honey, I've got the time. We'll go honky tonkin, and we'll have a time."* The Cross Roads, a 1930s roadhouse on Route 20 near Oxford, Massachusetts, could easily have provided the inspiration for the lyrics to this country-western classic. (Courtesy of author's private collection.)

ON THE FRONT COVER: Dud's Gas Station must have been a popular stop for motorists on Jacob's Ladder Trail. Customers could fill up the tank, enjoy the scenery and fresh air, relax by the lake, and possibly see if the fish were biting. (Courtesy of author's private collection.)

ON THE BACK COVER: Historic Route 20 played a vital role in the economy of the towns along its path. Most commonly, the route followed Main Street through the business district. (Courtesy of author's private collection.)

POSTCARD HISTORY SERIES

Along Massachusetts's Historic Route 20

Michael J. Till

ARCADIA
PUBLISHING

Copyright © 2012 by Michael J. Till
ISBN 978-0-7385-9247-3

Published by Arcadia Publishing
Charleston, South Carolina

Printed in the United States of America

Library of Congress Control Number: 2011944465

For all general information contact Arcadia Publishing at:
Telephone 843-853-2070
Fax 843-853-0044
E-mail sales@arcadiapublishing.com
For customer service and orders:
Toll-Free 1-888-313-2665

Visit us on the Internet at www.arcadiapublishing.com

To all who remember the crowding and heat in the back seat of the family sedan before the days of air-conditioning, iPods, and smartphones.

CONTENTS

ACKNOWLEDGMENTS

Thanks are due to the long-ago civic leaders and business owners who had the foresight to recognize the value of picture postcards in promoting their communities. These visual and historic records provide invaluable insights into the way it was in the days when two-lane highways and "mom and pop" tourist courts reigned supreme. Thanks also to the vendors of vintage postcards, without whose help this book would have been more difficult, if not impossible. Many searched for Route 20 cards for me, which was greatly appreciated. The same is true for persons responsible for modern websites describing towns and historical sites on Route 20. I have borrowed freely from their descriptions and wish to acknowledge their contributions.

Librarians and staffs of county historical societies and museums along Route 20 were helpful in directing me to interesting information about the road. Many shared personal memories of the postcard sites, and if someone did not know the answer to a question, their telephone call to a longtime resident of the community usually produced the information. Thus, many grandparents, uncles, aunts, and community elders contributed indirectly to this book.

Special thanks go to the Jacob's Ladder Scenic Byway Advisory Board and to Steve Hamlin in particular for his valuable assistance throughout this project. I hope this book will enhance the work the organization is doing to promote and preserve the history of both Jacob's Ladder Trail and Route 20 in Massachusetts.

Last, but certainly not least, I wish to thank my wife, Christine, for her help. A librarian herself, she knew sources of information and how to access them. She also was an excellent collaborator as we drove along Route 20 researching specific sites. Many of her observations have been incorporated into the captions in the book.

INTRODUCTION

Route 20 across the United States owes its origin to the Federal Aid Highway Act of 1921. This legislation provided funding for development and maintenance of seven percent of each state's road system, provided the roads were "interstate in character." Thus, the original federal highways were not new roads, but rather existing roads that could contribute to a nationwide transportation system. The roads to be included were identified by 1923, and in 1926, the first Federal Highway System came into existence. The numbering system that was adopted is still in use today. Major east-west routes were assigned a number ending in "0," and the numbering sequence was from north to south. From 1926 to 1940, Route 20 extended from Boston to the east entrance of Yellowstone National Park. In 1940, the western section was completed to Newport, Oregon, making Route 20 the northernmost of the true cross-country highways, and at more than 3,365 miles, the longest. Although not as famous as its cousins Route 30 (much of which coincided with the original Lincoln Highway) or Route 66 (which is not cross-country), Route 20 nonetheless served with equal importance in introducing automobile and truck traffic across America.

Highway officials in Massachusetts chose wisely in selecting the roads to be incorporated into Route 20. Starting at Boston's busy Kenmore Square and extending to the utopian Shaker Village at the New York border, the new federal highway crossed Massachusetts through some of the most interesting countryside in the eastern United States. By incorporating portions of the original Boston Post Road and Jacob's Ladder Trail, two of the state's most historic highways became part of Route 20. The newly designated road was historic, beautiful, and practical. It more than fulfilled the interstate mandate of the original legislation.

From the very beginning, Route 20 was unique. Two-lane highways were the standard of the day, and as Massachusetts's main east-west highway, it was the road to follow for both personal and commercial travel. It connected Boston with other major cities, including Worcester, Springfield, and Pittsfield; yet through much of Massachusetts, Route 20 was simply a rural byway passing from village to village and Main Street to Main Street. The charm and beauty of rural Massachusetts was epitomized along the road, and fortunately it has survived almost entirely intact. To this day, it remains a "country highway." The later interstate highways parallel Route 20 rather than being superimposed directly on top. While it is true that urban sprawl has taken its toll and certain sections have been realigned and widened to four lanes with modern bypass options around some cities, in most places the roads that carried "Original" Route 20 still exist. Local numerical or street names may have been assigned, but with a bit of effort one can still follow historic Route 20 across the state much as our ancestors did in decades gone by.

Early motorists got a close-up view of the towns and cities along their path and took advantage of their stores, restaurants, service stations, and tourist accommodations. City officials and entrepreneurial merchants quickly recognized the value of advertising their wares to the traveling public. Inexpensive or even free picture postcards were a popular vehicle for showing off their cities. Professionally produced picture postcards provided a convenient record of the trip and were typically less expensive and of higher quality than travelers could produce with their own cameras. Many picture postcards found their way into personal scrapbooks, and these postcards provide the basis for this book.

Along Massachusetts's Historic Route 20 is not a book of roadside curiosities, although Route 20 has had its share. Rather, the purpose is to recreate a journey across Massachusetts as close to its original route as possible, using vintage picture postcards as illustrations. It is intended to give a glimpse into where early travelers might have stopped for gas, to eat, or to spend the night—and especially what they would have seen along the way. The route was determined by following road maps and travel guides from the 1920s through the 1940s and extrapolating information to current streets and roads. Whenever possible, local knowledge of the route was included. The postcards show main streets, service stations, diners, tourist homes, cabin courts, and early motels. Notable scenic and historic locations along the route are also included. A large majority of the illustrations were located directly on historic Route 20 or could be viewed from the highway. All are from communities through which Route 20 passed and would have been logical locations for travelers to visit. The overall objective is to provide a guide as well as a nostalgic record for anyone wishing to replicate the experience of driving across Massachusetts on Route 20 during the pre-interstate era.

In recognition of Route 20's unique qualities of scenic beauty and quaint villages and its significant contribution to transportation in Massachusetts, the Jacob's Ladder Trail section of Route 20, which extends from Russell to Lee in Berkshire County, has been designated a Massachusetts Scenic Byway.

One

GREATER BOSTON

Historic Route 20 began its 3,365-mile journey across the United States at Governor's Square in the heart of Boston's famous Back Bay District, although in 1932, the name was changed to Kenmore Square, which it retains to this day. The square is the result of the convergence of three main thoroughfares: Commonwealth and Brookline Avenues and Beacon Street. Kenmore Square has long been one of Boston's most lively commercial and entertainment districts, abounding in restaurants, shops, and upscale hotels.

For the first several miles on a westward journey, Route 20 followed Commonwealth Avenue through highly populated metropolitan neighborhoods where the road passed several unique and historical sites. Fenway Park, home of the Red Sox, is just steps from Kenmore Square, and the Boston Braves played at Brave's Field, located only one mile farther west. Until the Braves moved to Milwaukee in 1952, Commonwealth Avenue was the only street in America that could boast of two major league baseball clubs on its doorstep. Boston University, one of the nation's preeminent institutions of higher education, has occupied much of the land between Kenmore Square and Boston's western city limits since the 1920s.

The Charles River is the demarcation between Boston and its western suburbs. It, too, has a remarkable history. Early explorers followed the river inland and opened the frontier. The river provided power for mills and factories along its banks, enabling villages to thrive and stabilize the area's economy. Like Boston, the communities of Watertown, Waltham, and Weston had been well established for almost 200 years before Route 20 was designated a federal highway. The ensuing years have seen growth that has melded these communities into a contiguous metropolitan area now recognized as Greater Boston, but they still retain their individual identities. Their historic main streets, village greens, and impressive civic, commercial, and residential buildings along Route 20 provide an excellent picture of life as it was during the early years of automobile travel.

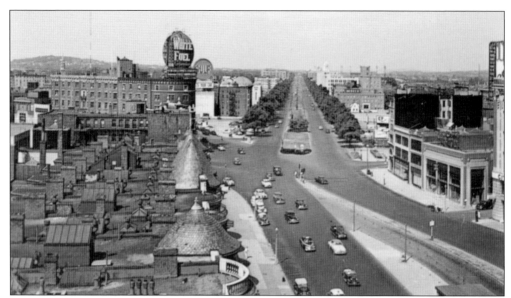

KENMORE SQUARE, BOSTON. Kenmore Square has been the eastern terminus of Route 20 since the road was declared a federal highway in 1926. The square is formed by the junction of three main thoroughfares: Commonwealth Avenue, Beacon Street, and Brookline Avenue. This view from the early 1930s shows Route 20 extending west from Kenmore Square on the first leg of its 3,365-mile journey across the country.

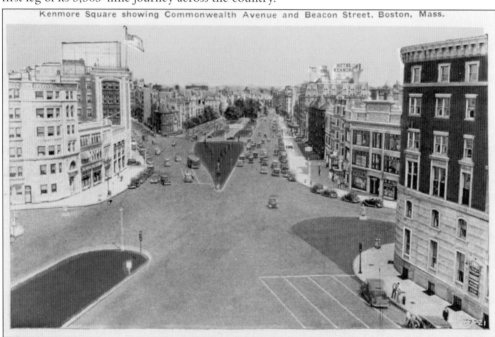

KENMORE SQUARE (LOOKING EAST), BOSTON. For decades, Kenmore Square's location near Fenway Park (home of the Boston Red Sox), Boston University, and many of the city's most famous hotels has made it a center of activity in Boston's Back Bay district. Travelers arriving in Boston from the west would have had this view of the square and the skyline of Boston straight ahead down Commonwealth Avenue.

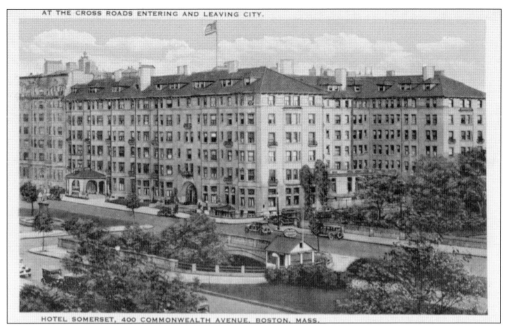

HOTEL SOMERSET, 400 COMMONWEALTH AVENUE, BOSTON, MASS.

HOTEL SOMERSET, 400 COMMONWEALTH AVENUE, BOSTON. Located just steps from Kenmore Square, the Somerset was famous as a wining, dining, and meeting place for discriminating Bostonians and visitors to the city. The hotel's Rib Room was said to be Boston's first restaurant to raise the preparation of beef to a high and elegant art. It proclaimed, "Everything about the Rib Room is fabulous—but especially the beef."

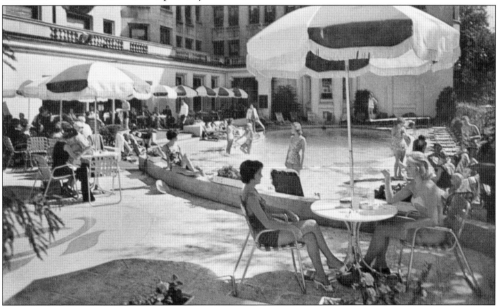

HOTEL SOMERSET'S PATIO AND POOL, BOSTON. The Somerset Hotel's beautiful patio and pool was a favorite gathering spot for Boston's society during the first half of the 20th century. This postcard is not dated, but the predominance of young women in the photograph might indicate that it was taken during World War II, a time when many of their male counterparts were serving in the military forces.

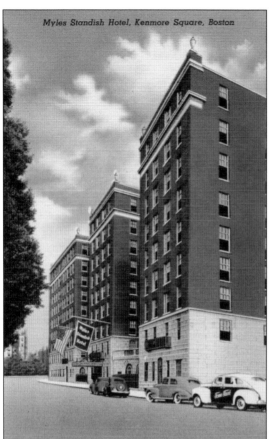

Myles Standish Hotel, Kenmore Square, Boston

MYLES STANDISH HOTEL, 610 BEACON STREET, BOSTON. This hotel opened in 1928, and was an area landmark throughout the early years of Route 20. One of Boston's finest, it was patronized by the rich and famous including Babe Ruth, who preferred Suite 818. The hotel was purchased by Boston University in 1949 and converted into student housing, where Martin Luther King was a resident while a graduate student.

HOTEL KENMORE, COMMONWEALTH AVENUE AT KENMORE SQUARE, BOSTON. In the 1930s and 1940s, the Kenmore was one of Boston's newest and finest hotels, housing all major league baseball teams when they played the Red Sox at Fenway Park. It boasted 400 luxurious air-conditioned rooms, all with circulating ice water, a radio, and an emergency sound system. The hotel's Sportsman's Bar & Grill was the rendezvous of celebrities from the radio and sports world.

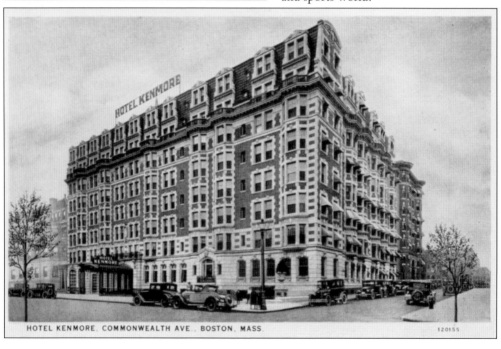

HOTEL KENMORE, COMMONWEALTH AVE., BOSTON, MASS. 120155

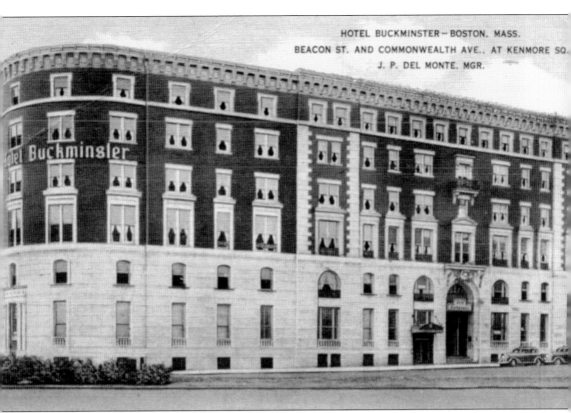

BOSTON HOTEL BUCKMINSTER, 645 BEACON STREET, BOSTON. Boston Hotel Buckminster, designed by famed architect Sanford White, dates to 1897 and was one of the first luxury hotels in Boston's Back Bay district. It featured 200 rooms and spacious apartment suites and was the largest building on the square at that time. The Hotel Buckminster has been the site of two notable historic events. In September 1919, a professional gambler named Joseph "Sharp" Sullivan met with Chicago White Sox player Arnold "Chick" Gandil in a guestroom of the hotel where it was agreed that the White Sox, the overwhelming favorite, would throw the 1919 World Series to the Cincinnati Reds. This became known as the infamous "Black Sox Scandal" and resulted in the lifetime suspensions of eight White Sox players including Shoeless Joe Jackson. The second event occurred in July 1929. WNAC Radio, with new studios in the Hotel Buckminster, arranged the first network broadcast in the history of radio with station WEAF in New York City using a 100-foot antenna connected to the building's roof with a clothesline.

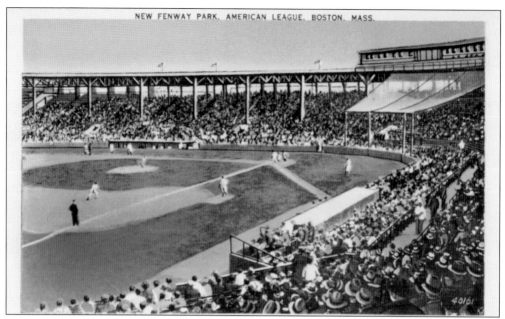

FENWAY PARK, BOSTON. The home of the Boston Red Sox professional baseball team opened on April 20, 1912. Whereas the original stadiums in most other major league cities have been replaced, this venerable venue remains almost as it did 100 years ago. When this photograph was taken in the 1930s, baseball was still a daytime game, and lights had not yet been installed in the stadium.

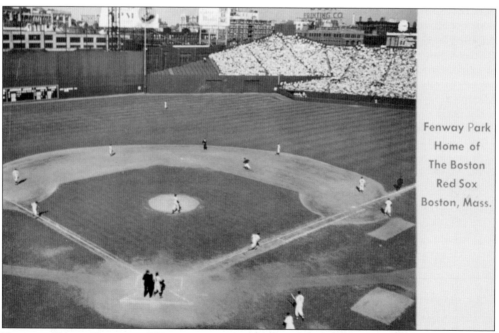

Fenway Park
Home of
The Boston
Red Sox
Boston, Mass.

FENWAY PARK, BOSTON. This 1940s view of Fenway Park shows its famous left field wall, dubbed the Green Monster because of its unusual height, at the top left of the photograph. The on-deck player in the lower right of the photograph wearing jersey number nine is the Red Sox's famous slugger Ted Williams.

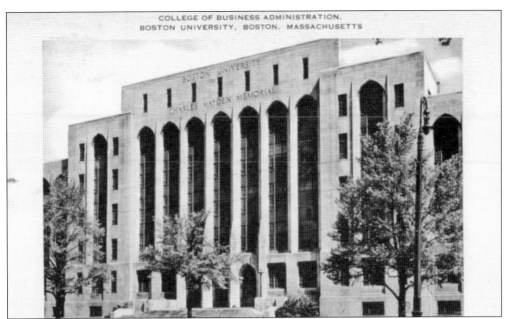

BOSTON UNIVERSITY, COMMONWEALTH AVENUE. The Boston University campus extends for several blocks along Route 20 west of Kenmore Square. The Charles Hayden Memorial Building (above) is home to the College of Business Administration. It was built in 1938, subsequent to a generous donation by Charles Hayden, founder of the investment-banking firm Hayden, Stone & Company. The chapel (below) was named in honor of Daniel L. Marsh, who coincidentally was installed as president of Boston University in 1926, the same year in which Route 20 was commissioned as a federal highway. He served until 1950 and oversaw the consolidation of the Charles River campus. The chapel was constructed between 1939 and 1948 at a cost of $1 million. It is located at the center of campus to demonstrate the centrality of religion to education.

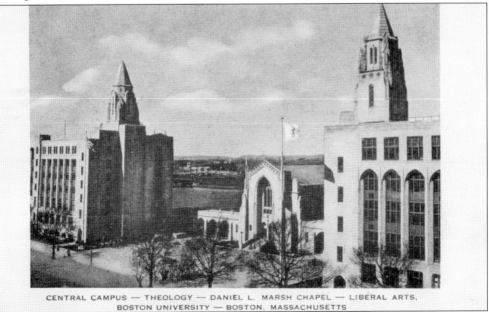

CENTRAL CAMPUS — THEOLOGY — DANIEL L. MARSH CHAPEL — LIBERAL ARTS,
BOSTON UNIVERSITY — BOSTON, MASSACHUSETTS

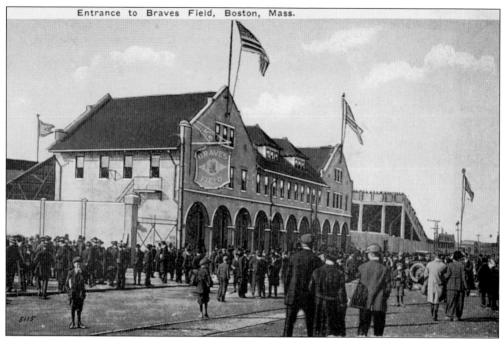

Entrance to Braves Field, Boston, Mass.

BRAVES FIELD, COMMONWEALTH AVENUE, BOSTON. Route 20 was unique in that it had two major-league stadiums along its route, both in Boston and only a few blocks apart. Braves Field, the home of the Boston Braves, opened on April 18, 1915, and continued as the team's field until September 21, 1952, when the Braves moved to Milwaukee. At the time it opened, its capacity was 42,000 and was the largest ballpark in the country. Due to its larger capacity, it was used by the Boston Red Sox for their home games during the World Series in 1915 and 1916. The above photograph shows the front facade as it appeared in the 1920s. The lower photograph shows the field during a night game after lights were installed in 1946.

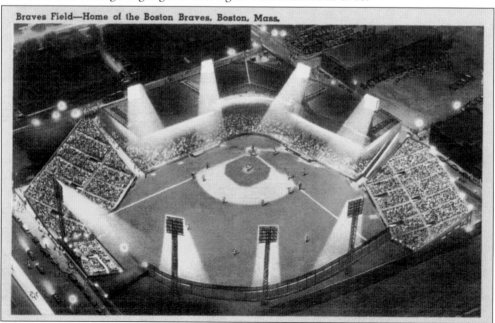

Braves Field—Home of the Boston Braves, Boston, Mass.

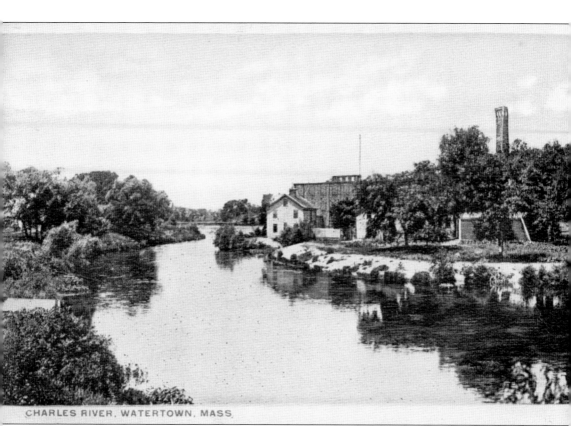

CHARLES RIVER, WATERTOWN, MASS.

CHARLES RIVER, WATERTOWN. The Charles River flows into Boston from the west and is the boundary between Boston proper and the suburbs. The river played a significant role in expanding the frontier into the wilderness. Early explorers followed the river inland, where settlements that were established eventually grew into present-day suburbs. The river provided a dependable source of power for the grain mills and small factories built along its banks. The first community west of Boston through which Route 20 passes is Watertown, where this card shows the Charles flowing peacefully and scenically through the center of town near the public square.

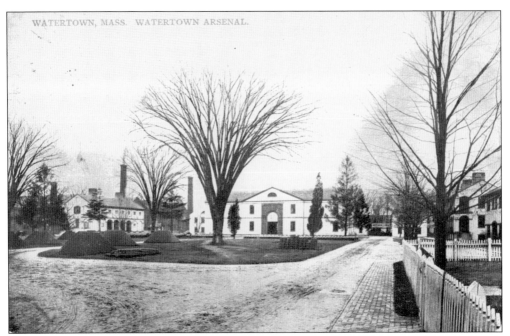

ARSENAL, WATERTOWN. Immediately after crossing the Charles River, a westbound motorist on Route 20 would view the Watertown Arsenal, established in 1816 to receive, store, and distribute ordnance to Army units in the field. Although initially containing only 12 buildings located along the river, the arsenal enjoyed steady growth for more than a century. Over the years, its function changed from storage and distribution to the manufacture of gun carriages.

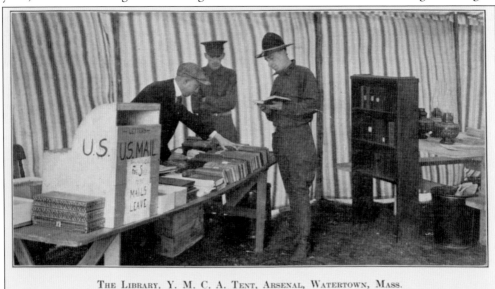

THE LIBRARY, Y. M. C. A. TENT, ARSENAL, WATERTOWN, MASS.

ARSENAL LIBRARY AND POST OFFICE, WATERTOWN. The Watertown Arsenal reached its zenith during World War I. A neatly uniformed "doughboy" from that era is pictured visiting the library and post office provided by the YMCA. Following World War II, the arsenal began a slow decline and eventually ceased operation in 1968. The site is in the National Register of Historic Places, but the land and buildings were sold for civilian use.

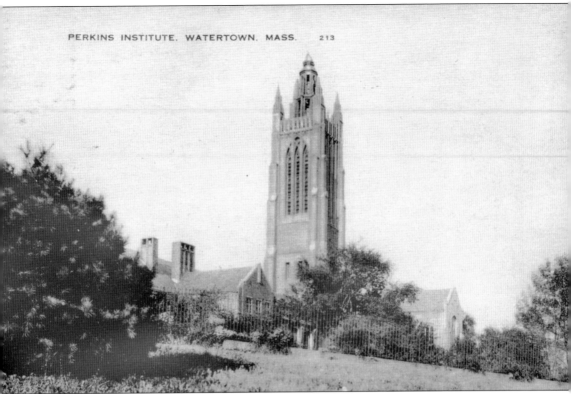

PERKINS INSTITUTE, 175 NORTH BEACON STREET, WATERTOWN. The New England Asylum for the Blind, the first school in the United States for blind students, was founded in 1829. Originally located in Boston, the school moved from site to site as its student body grew. The name changed sequentially to the Perkins Institution and the Massachusetts School for the Blind, eventually being named the Perkins School for the Blind. In 1912, the school moved to its present campus in Watertown. While still in Boston, the school became home to seven-year-old Helen Keller, who was blind and deaf. Her mentor was Anne Sullivan, whose teaching skill coupled with Keller's intelligence enabled her to learn to read Braille and to speak. She became a successful educator, author, and inspiration for thousands of children who are blind and deaf. Perkins's main building, with its tower crowned by a symbolic lantern of education, is named after the school's first director, Samuel Gridley Howe. His wife was Julia Ward Howe, abolitionist and author of "The Battle Hymn of the Republic."

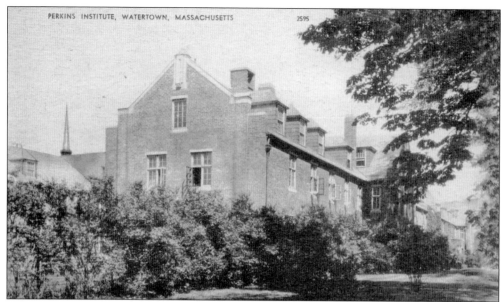

PERKINS INSTITUTE, WATERTOWN. The success enjoyed by the Perkins Institute in the education of blind and deafblind pupils resulted in continued growth of the school. Additional classroom, dormitory, and research buildings were added. In 1931, the Perkins Institute established the Perkins Braille and Talking Book Libraries, which brought literature to visually impaired persons throughout the country.

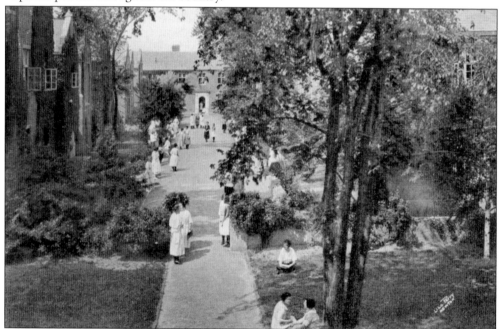

GIRLS' CLOSE, PERKINS INSTITUTE, WATERTOWN. Although Helen Keller attended the Perkins Institute while it was still located in Boston, she visited the Watertown campus on many occasions throughout her lifetime, where her influence continues to be felt. She and her mentor, Anne Sullivan, were formally recognized when the former Girls' Courtyard on the west side of the Howe Building was named the Keller-Sullivan Memorial Garden.

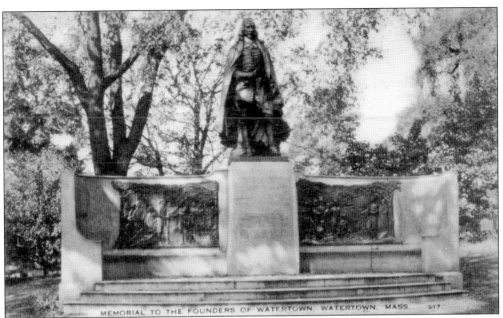

MEMORIAL TO THE FOUNDERS OF WATERTOWN. The centerpiece of this monument, dedicated in 1931, is a nine-foot bronze statue of Sir Richard Saltonstall, who, in 1661, led a group of English settlers up the Charles River to the location of present-day Watertown. On either side of the statue, bas-reliefs showcase two other historical moments in Watertown's history: Roger Clap's Landing in 1630 and the anti-tax protest of 1632.

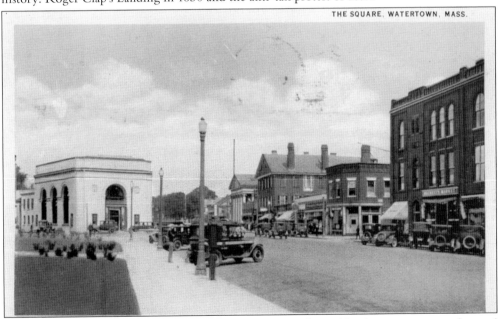

THE SQUARE, WATERTOWN. The Watertown Square is formed by the convergence of several primary and secondary streets. Route 20 proceeds directly through the square, entering from Boston on North Beacon Street and exiting to the west on Main Street. This view shows the square as it appeared when the card was posted in 1929. The white building with the prominent arch was the Union Market National Bank.

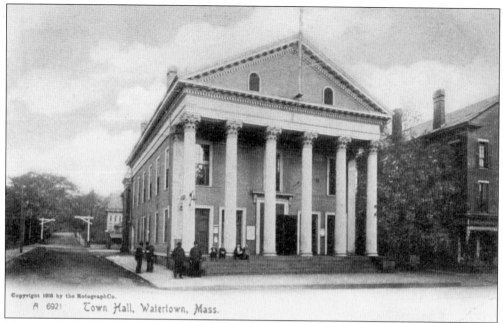

Copyright 1905 by the RotographCo.
A 6921 Town Hall, Watertown, Mass.

TOWN HALL, WATERTOWN. Dating to before the Civil War, the original Watertown Town Hall was several decades old when this card was published in 1905, and it continued to serve the community until the mid-20th century. The building housed city offices, the library, and jail. The stately, six-columned building can be seen in the center of the previous photograph, across Main Street from the Union Market National Bank.

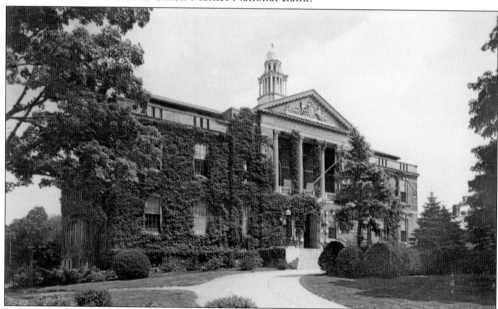

ADMINISTRATION BUILDING, WATERTOWN. This attractive brick government building topped with a distinctive cupola replaced the old town hall shown in the two previous photographs. It was a product of the Works Progress Administration's (WPA) recovery program following the Great Depression. Built in the 1930s, it is located on Main Street only a short distance west of the Watertown Square.

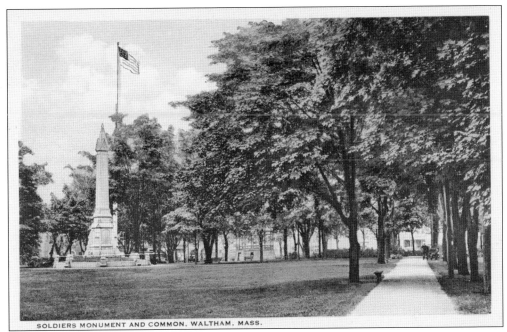

SOLDIERS MONUMENT AND COMMON, WALTHAM, MASS.

SOLDIERS MONUMENT AND COMMON, WALTHAM. Like so many New England cities, the common in Waltham occupied a central location and was a focal point for the community. Structures within the common include the city hall, a monument dedicated to the soldiers who fought in prior wars, and a bandstand where concerts could be enjoyed by locals and visitors alike.

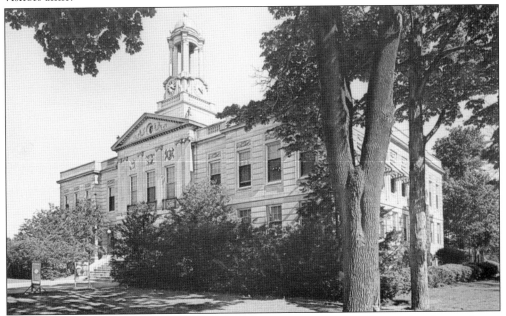

CITY HALL, 610 MAIN STREET, WALTHAM. Waltham's City Hall occupies the northwest corner of the common facing Main Street. Ground was broken for the building in 1925 and was dedicated in 1927, thus it has been a roadside landmark throughout the entire existence of Route 20.

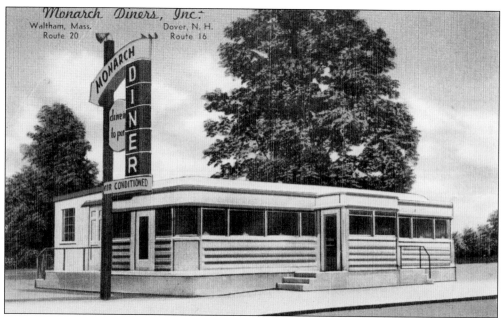

MONARCH DINER, MAIN STREET WALTHAM. This classic stainless-steel diner was manufactured by the O'Mahoney Diner Company of Elizabeth, New Jersey. For many years, it occupied a prominent position on Route 20 in Waltham. In 1973, the diner was moved to Salisbury, Massachusetts, where it became Linda's Jackpot Diner. In 1988, it was sold again and eventually moved to Tilton, New Hampshire, where it opened as the Tilt'n Diner in 1992.

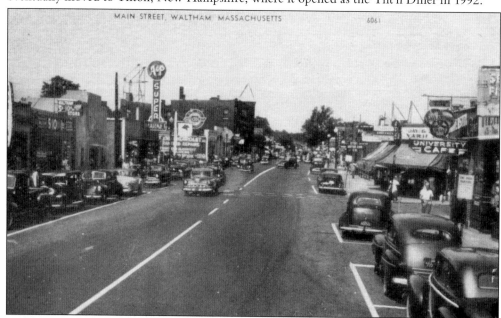

MAIN STREET, WALTHAM. Before the advent of urban sprawl, strip malls, and big box stores, commerce in most towns took place on Main Street. Busy retail establishments made business districts exciting places to shop and meet one's neighbors. Route 20 followed Main Street through most towns along its route. On an east-to-west journey, one of the first was Waltham, where this postcard was produced in the 1940s.

24

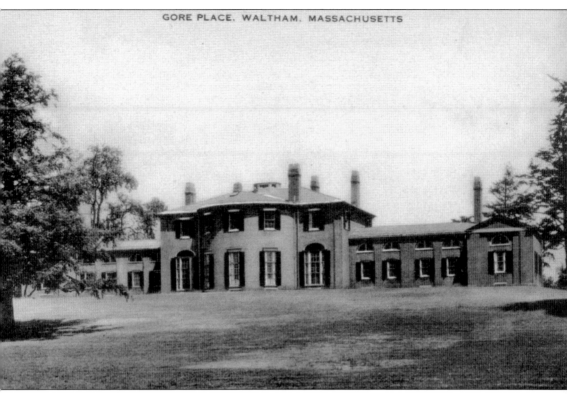

GORE PLACE, 52 GORE STREET, WALTHAM. This home of Massachusetts's seventh governor and former senator, Christopher Gore, and his wife, Rebecca, dates to 1806. Gore had been a successful Boston attorney for several years, during which time he had purchased land in the village of Waltham for the purpose of building their summer home. The 22-room redbrick building replaced their former wooden house on the property, which had burned to the ground in 1799. The Gores were prominent in Boston society, and guests at their home included such dignitaries as Daniel Webster and James Monroe. Gore Place has been called the "Monticello of the North" and is considered to be the most significant Federal period mansion in New England. The design of the mansion is attributed to Parisian architect Jacques-Guillaume Legrand, and the formal grounds were inspired by English landscape architect Sir Humphrey Repton. The estate is now a museum featuring American, European, and Oriental furnishings. It is listed in the National Register of Historic Places.

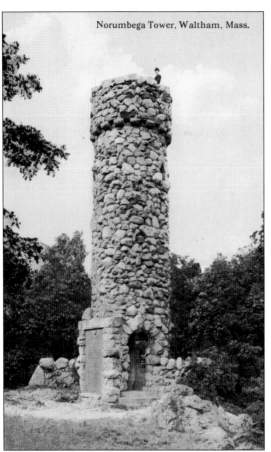

Norumbega Tower, Waltham, Mass.

NORUMBEGA TOWER, BETWEEN WALTHAM AND WESTON. Norumbega Tower, located approximately two miles south of Route 20, was erected in 1889 at the confluence of the Charles and Stony Brook Rivers. The latter river separates Waltham and Weston, and both cities lay claim to the monument. Built by Harvard professor Eban Horsford, the tower commemorates legendary Fort Norumbega, which he believed had been built on this site by Viking explorers.

TOWN HALL AND GREEN, WESTON. Like its neighbor Waltham, the central park is the focal point of the city of Weston, but here it is called the Green. It has been the site for band concerts and other community gatherings since the town was founded. Weston's town hall, a classic brick Federal-style building topped with a six-sided cupola, overlooks the green from the north.

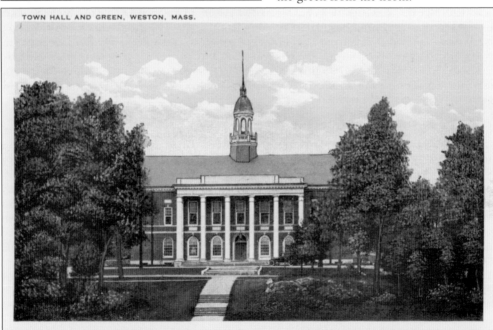

TOWN HALL AND GREEN, WESTON, MASS.

Two

THE BOSTON POST ROAD

When Benjamin Franklin was appointed deputy postmaster for the northern colonies in 1751, he immediately set about improving the roads used by post riders to deliver the mail. Most roads of the day followed original Indian trails and later evolved into farm-to-market roads providing access for farmers along the way. Franklin developed an odometer attached to the wheel of his carriage that measured the miles he had traveled. Mileposts were eventually installed, many of which still exist. These markers guided early travelers and were used to determine the costs for postage. The road from Boston to just outside of Springfield became known as the Boston Post Road. It played an important role in transporting the country's founding fathers between their homes in New England and the Continental Congress in Philadelphia. John Adams was known to have used the road on many occasions, and records still exist of his stays at taverns along the way. During the Revolutionary War, the route was vital for the movement of troops and equipment.

The Boston Post Road eventually became a main transit route in Massachusetts and was the logical choice for incorporation into Route 20 when federal highways were designated in 1926. In recognition of its unique history, much of Route 20 in the area still carries the Boston Post Road name. Years of use have seen the evolution of taverns and stagecoach stops into villages and some villages into cities, Marlboro and Worcester being notable examples. A robust economy was present, and early motorists had no difficulty in finding accommodations and services to meet their needs. These amenities greatly contributed to the rapid rise in the popularity of automobiles in the early years of the 20th century. Driving enthusiasts were introduced to interesting communities and beautiful lakes and vistas on their journeys. Historic sites, such as Longfellow's Wayside Inn near Sudbury and the White City Amusement Park in Worcester, added diversity to a drive along the highway.

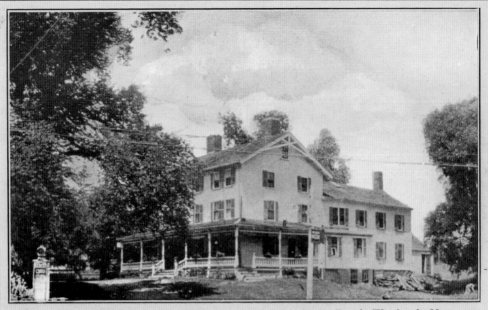

1642 Wayland Inn on the Boston-to-Worcester State Road, Wayland, Mass.

Inside at Seiler's Ten Acres

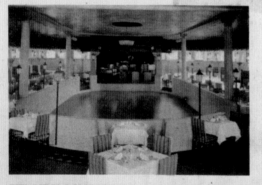

TEN ACRES BALLROOM . . . its sunken floor, softly lighted from Italian street lamps, cozy booths under tile roofs supported by Venetian colonnades—music entrancing—food that satisfies the connoisseur—the right kind of people about you

THE COCKTAIL LOUNGE.. just apart from the ballroom fine liquors combined to make your favorite drink taste even better a rendezvous for the discriminating

THE TERRACE . . . overlooking broad lawns, where families are wont to gather for Sunday dinner in the Continental style groups gather here on weekdays as many as 150

Where good food and good music combine to please !

WAYLAND INN, ON THE BOSTON–TO–WORCESTER STATE ROAD, WAYLAND. When Route 20 was designated a federal highway in 1926, it followed the Boston Post Road through this section of Massachusetts. One of the first communities along the road was Wayland, where this large tourist home with an inviting front porch was on the "Boston-to-Worcester State Road," the local name before Route 20 attained common usage.

SEILER'S TEN ACRES, ROUTE 20, WAYLAND. This 1940s restaurant/nightclub, "where music and food combine to please," was ideally located only 30 miles from Boston and Worcester, Massachusetts. The decor was up-to-date and featured the latest in Art Deco design, including the sunken dance floor, which was softly lit by Italian street lamps. Patrons could dine in the ballroom, the cocktail lounge, or on the terrace overlooking the broad lawns.

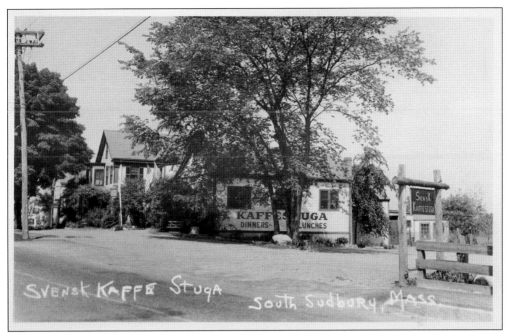

SVENSK KAFFE STUGA, 394 BOSTON POST ROAD, SOUTH SUDBURY. Established in 1928, the "Swedish coffee house" billed itself as "a little bit of Sweden." The restaurant featured lunches, dinners, and afternoon coffee and catered to birthday and anniversary parties. Swedish novelties also were for sale.

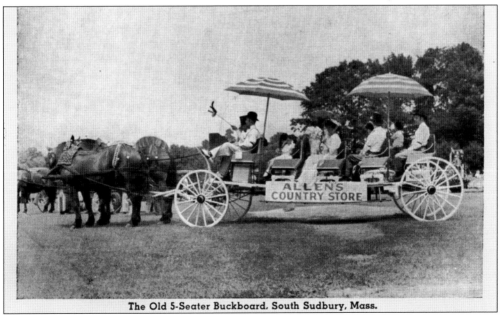

The Old 5-Seater Buckboard. South Sudbury, Mass.

ALLEN'S COUNTRY STORE, SOUTH SUDBURY. The back of this card describes Allen's as an "Old Fashioned General Store selling everything from a Buggy Whip to a Bustle." Rides in the old five-seater buckboard behind large draft horses were especially fun for children. In recognition of the nearby Wayside Inn, Allen's also contained an unusual collection of Henry Ford memorabilia.

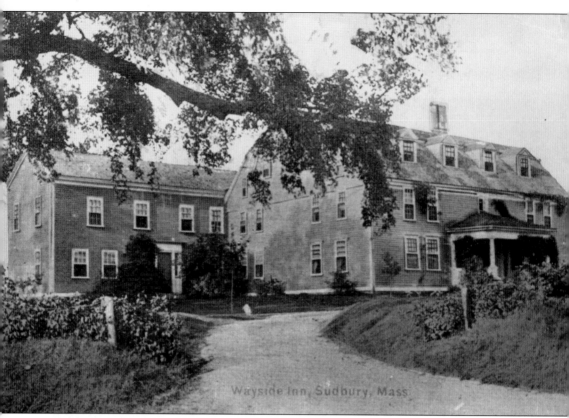

HOWE TAVERN, WAYSIDE INN, SOUTH SUDBURY. Records show that an inn has been located at the site of the Wayside Inn since at least 1716. The Howe family operated it for over four generations, but with the advent of the railroads, stagecoach travel decreased and it closed as a public house for almost 40 years. It reopened when automobile travel became more common and has remained in operation since then. The inn provided the setting for Longfellow's *Tales of a Wayside Inn*, first published in 1863; thereafter, the inn has been referred to as the Wayside Inn. This building, the actual Howe Tavern, contained dining rooms, the bar, kitchen, and guest rooms. It claims to be the oldest operating inn in the United States. Henry Ford purchased the surrounding acreage in 1923, and the original buildings were preserved and other historic buildings were moved to the site to create both a working inn and a museum. It is thought that Longfellow visited the inn on only two brief occasions. The Wayside Inn is a National Historic Site.

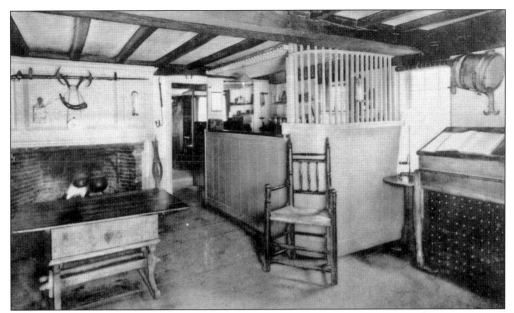

THE OLD BAR ROOM, WAYSIDE INN, SOUTH SUDBURY. For almost 300 years, patrons of Howe's Tavern have gathered in this bar room for conversations and refreshments. Originally, the Boston Post Road (eventual Route 20) passed directly in front of the inn. When Henry Ford acquired the property, he had the highway moved to preserve the ambiance of the site. The original road is now called the Wayside Inn Road.

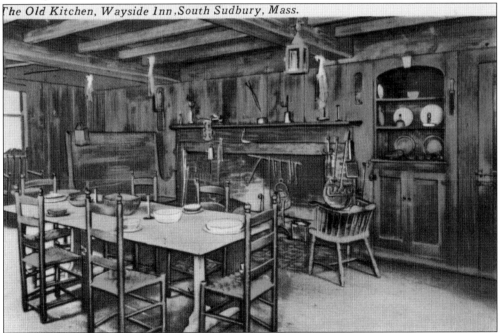

The Old Kitchen, Wayside Inn, South Sudbury, Mass.

THE OLD KITCHEN, WAYSIDE INN, SOUTH SUDBURY. The kitchen, which also served as the dining room, was central to the activities of all early inns and taverns as well as the gathering place for travelers. If walls could talk, there is no doubt that the stories they could tell about the visitors to this inn over the years would fill volumes.

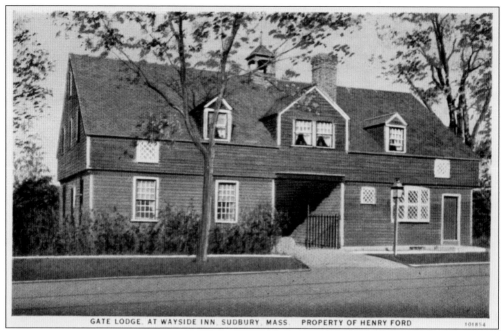

GATE LODGE AT WAYSIDE INN, SUDBURY. Through the philanthropy of Henry Ford in the 1930s, this 18th-century building was restored on the grounds of Longfellow's Wayside Inn.

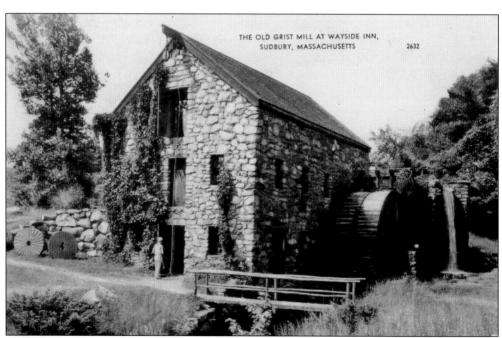

GRISTMILL, WAYSIDE INN, SOUTH SUDBURY. Commissioned by Henry Ford, this mill was completed in 1929 and ground its first grist on Thanksgiving Day of that same year. It was built as a living museum to further Ford's interest in educating the public about the role of small industries in an agrarian economy. The flour produced at the mill is sold in the Wayside Inn General Store.

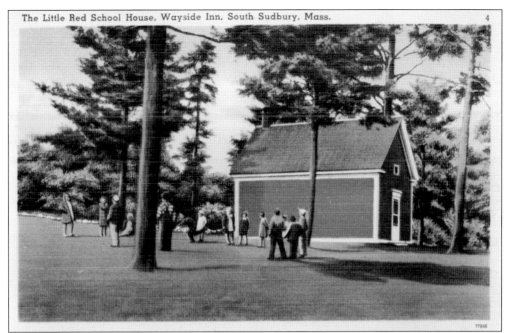

LITTLE RED SCHOOLHOUSE, WAYSIDE INN, SOUTH SUDBURY. According to folklore, Mary Sawyer, the self-proclaimed inspiration for "Mary had a Little Lamb," took her lamb to this school in 1815 and inspired the poem by Sarah Hale. Moved to Sudbury in 1927, it was an active school until 1951. Throughout her lifetime, Hale insisted that the poem was the product of her imagination and not based on an actual event.

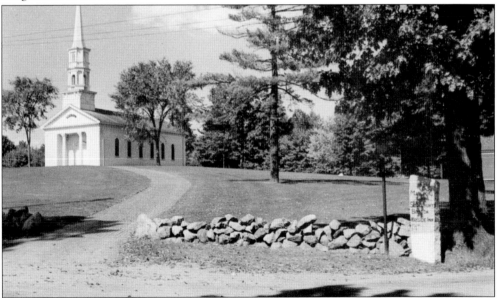

MARTHA MARY CHAPEL, WAYSIDE INN, SOUTH SUDBURY. This is one of six chapels built by Henry and Clara Ford in memory of their mothers. Built in 1940, the chapel sits atop a grassy knoll on the Wayside Inn grounds and over the years has become one of South Sudbury's best known landmarks. The steeple was inspired by spires designed by famous 18th-century architect Christopher Wren.

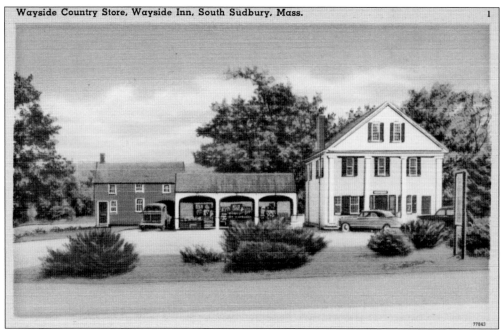

WAYSIDE COUNTRY STORE, SOUTH SUDBURY. Built before the Revolution, this building originally was located in the center of Sudbury, where it functioned as the post office, school, and general store. The second floor was used for community meetings and dances. In 1930, Henry Ford had the building moved six miles by oxen to its present location overlooking a pond beside the Boston Post Road. The exterior of the store and some outbuildings, including one housing an old-time candy store, are shown in the top photograph. The interior of the store (below) was restored to replicate a general store of the cracker-barrel era. Much early 20th–century merchandise was displayed on the long counter and in bushel baskets. The Wayside Country Store is among the most popular roadside attractions on Route 20, and few travelers pass by without stopping for a visit.

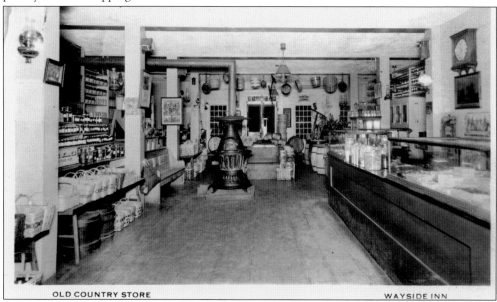

OLD COUNTRY STORE WAYSIDE INN

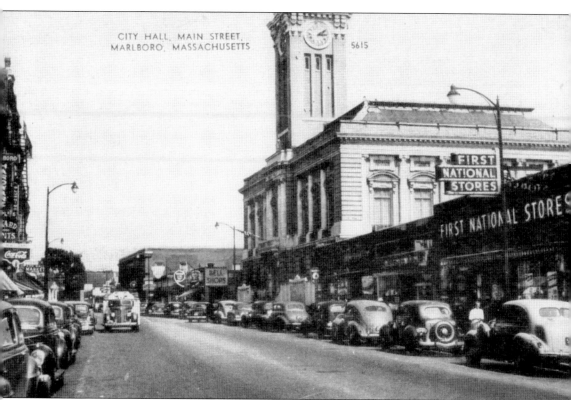

CITY HALL, MAIN STREET,
MARLBORO, MASSACHUSETTS 5615

MAIN STREET, MARLBORO. Founded in the 1660s and later a popular stop on the Boston Post Road, Marlboro (also spelled Marlborough) was a thriving community in the 1930s. City hall, with its imposing facade and clock tower, dominated the business district. Marlboro is home to a unique Civil War memento. Early in the war, a group of Marlboro soldiers was ordered to occupy the arsenal at Harper's Ferry, West Virginia, to prevent anything of value from falling into Confederate hands. This was the same arsenal that abolitionist John Brown had raided, which ultimately resulted in his capture and execution. The soldiers removed the bell from the firehouse and left it with a Mrs. Snyder, who had befriended them. After more than 30 years, it was recovered by some of the same soldiers who originally had taken it. They took the bell to Marlboro, where "John Brown's Bell" was proudly displayed at the Grand Army of the Republic (GAR) building on Main Street. The building was eventually torn down, and a special tower was built for the bell on the town's Union Common.

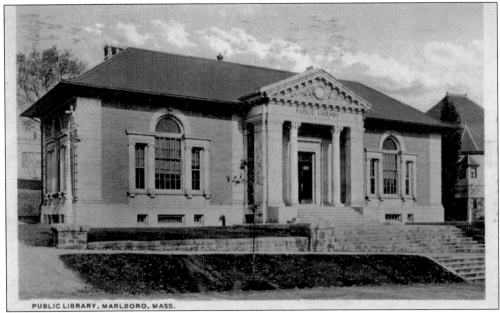

PUBLIC LIBRARY, MARLBORO, MASS.

PUBLIC LIBRARY, 35 WEST MAIN STREET, MARLBORO. In 1902, Andrew Carnegie presented the town of Marlboro with $30,000 to build a library. The style of the building is called "Carnegie Classical Revival" and is similar to other Carnegie libraries throughout New England. Modifications and additions have been made throughout the years, but the facade of the original building has remained true to the original design.

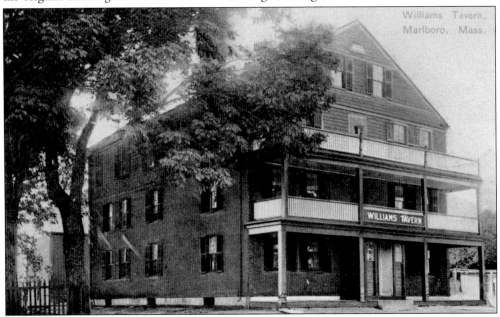

WILLIAMS TAVERN, MARLBORO. Abraham Williams built the original house on the site of William's Tavern around 1662. It was burned by Indians in 1875 or 1876 but was rebuilt the following year on the same site. It was a relay stop on stagecoach routes and was also where court was held. George Washington had his dinner here with dignitaries of the town on October 23, 1789. Today, only a roadside plaque marks the site.

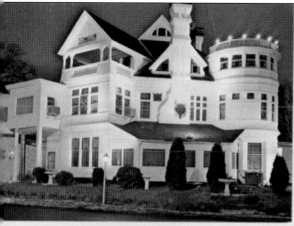

WHITE CLIFFS

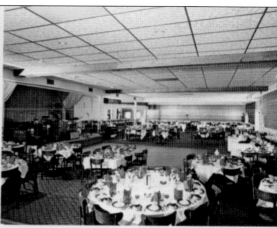

THE LEONARDO ROOM

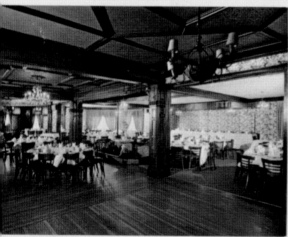

THE UPSTAIRS BANQUET ROOM

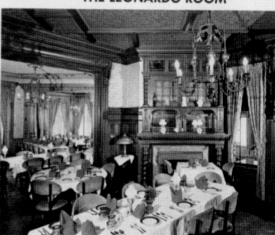

THE CYNTHIA WESSON ROOM

WHITE CLIFFS, 167 MAIN STREET, NORTHBORO (NORTHBOROUGH). Originally known as the Wesson Estate, White Cliffs was built in 1886 by Daniel Wesson as a summer home for his wife, Cynthia, a Northboro native. Wesson was a well-know inventor and manufacturer—specifically of Smith and Wesson Firearms—who after the Civil War became one of America's wealthiest industrialists. No expense was spared in the estate's construction, as Wesson employed skilled craftsmen from Italy to work on the tropical woods and marble used in each of the home's 32 rooms and 17 fireplaces. Unique for a house of the period, White Cliffs had a specially constructed aqueduct and pumping station that delivered hot and cold running water to every bedroom in the mansion. Today, White Cliffs is one of the area's premier function facilities.

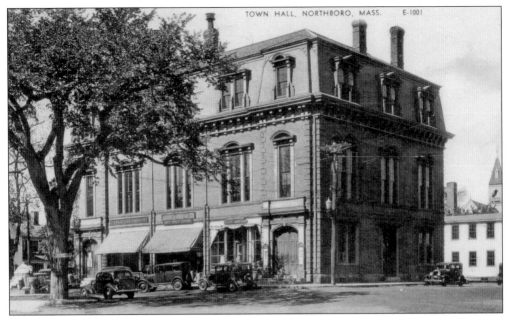

TOWN HALL, MAIN STREET, NORTHBORO. Construction of the old town hall began in 1868, so it had been serving the community for almost 70 years when this c. 1935 photograph was taken. The building is listed by the National Park Service as a Historical Architectural Monument largely due to its famous French-style Mansard roof, one of the best examples of this style in New England.

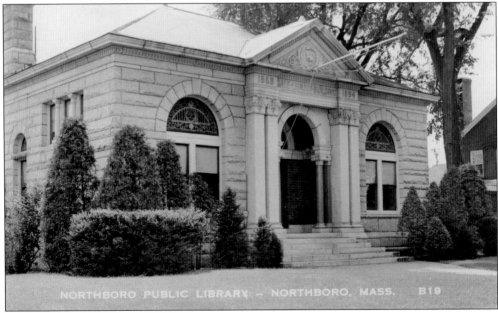

FREE PUBLIC LIBRARY, 34 MAIN STREET, NORTHBORO. Founded in 1868, this library owes its existence largely to one family. Capt. Cyrus Gale contributed $1,000 to start a public library in the town hall. In 1894, Captain Gale's son Cyrus Jr. donated land plus $30,000 to build the new, larger library. In contrast to many early libraries, which required a membership fee, everyone could use this library without paying.

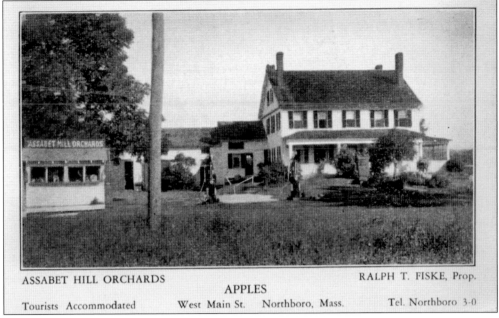

ASSABET HILL ORCHARDS RALPH T. FISKE, Prop.

APPLES

Tourists Accommodated West Main St. Northboro, Mass. Tel. Northboro 3-0

ASSABET HILL ORCHARDS, WEST MAIN STREET, NORTHBORO. Overnight guests were accommodated in the large house, which was the centerpiece of Assabet Hill Orchards. The establishment offered two gas pumps for the convenience of motorists, but there is no mention on the card of other automotive services. Apples were for sale at the stand to the left of the photograph.

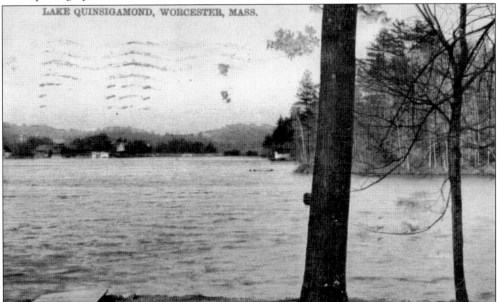

LAKE QUINSIGAMOND, WORCESTER. Lake Quinsigamond has been a major attraction in the Worcester-Shrewsbury area since the turn of the 20th century. Although relatively small—five miles in length and only a few hundred feet wide—it nonetheless has been a favorite recreational area. For decades, residents and visitors have enjoyed a variety of water sports on the lake and at the amusement parks located on the lakeshore.

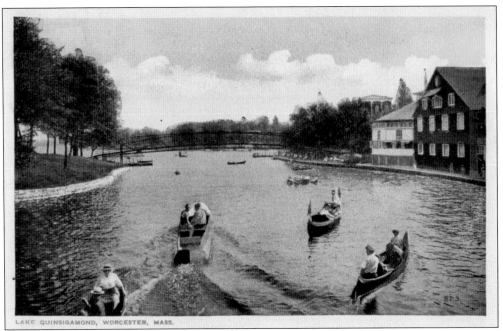

LAKE QUINSIGAMOND, WORCESTER, MASS.

LAKE QUINSIGAMOND, WORCESTER. The popularity of both canoeing and motorboating is evident in this photograph. In the distance, a footbridge connects the mainland with one of the eight islands located in the lake. The caption on the back of the card describes Lake Quinsigamond as the principal pleasure resort of Worcester.

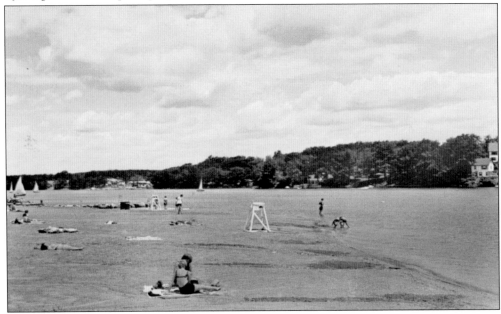

BATHING BEACH AT LAKE QUINSIGAMOND STATE PARK, WORCESTER. Three additional Lake Quinsigamond activities—sunbathing, swimming, and sail boating—were visible when this photograph was taken. The broad sandy beach was especially attractive on hot summer days. The narrow width of the lake is clearly shown, but this did not deter from enjoying the lake.

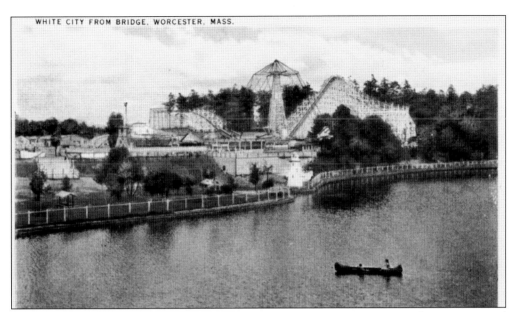

WHITE CITY AMUSEMENT PARK, WORCESTER. A popular tourist attraction in central Massachusetts, White City opened in 1905 and continued uninterrupted until 1960. Located on the western shore of Lake Quinsigamond, the park contained all the popular entertainment venues of the time including a midway, arcades, roller coaster, and many other rides. Its giant swing, Whirl of Airships, thrilled riders as they swung out over the waters of the lake.

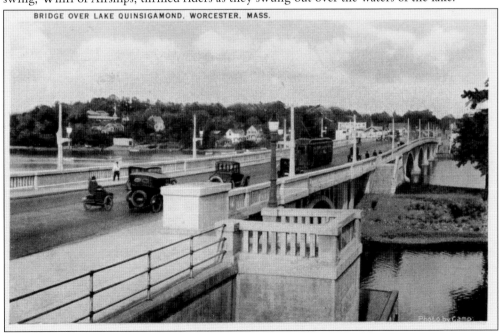

BRIDGE OVER LAKE QUINSIGAMOND, WORCESTER. This attractive concrete arch bridge opened in 1919 and has served Worcester ever since. From 1926 until 1933, Route 20 crossed this bridge before it was rerouted southwest of the city on the Hartford Turnpike. The bridge now carries Route 9 traffic. It remained true to its original design until 1973, when it was expanded to four lanes.

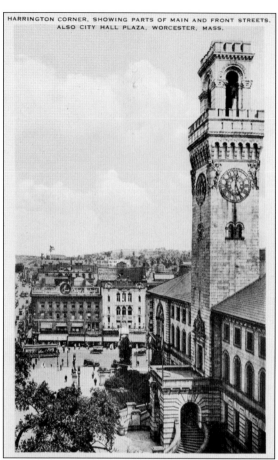

HARRINGTON CORNER, SHOWING PARTS OF MAIN AND FRONT STREETS, ALSO CITY HALL PLAZA, WORCESTER, MASS.

CITY HALL AND PLAZA, WORCESTER. The city hall in Worcester opened in 1898, and since that time it has been the downtown's predominant building. Designed by architects Robert Peabody and John Sterns in the style of an Italian palazzo, the massive structure is accentuated by the clock tower, which rises majestically above the building and can be seen for miles around (top photograph). Adding to the building's attractiveness is its location on City Hall Plaza, a large public space containing walking paths, flower gardens, and monuments (below). Throughout the years, City Hall Plaza has been the site of many civic events including homecomings for military personnel and recognition of persons who lost their lives in war. The Worcester City Hall and Plaza were added to the National Register of Historic Places in 1978.

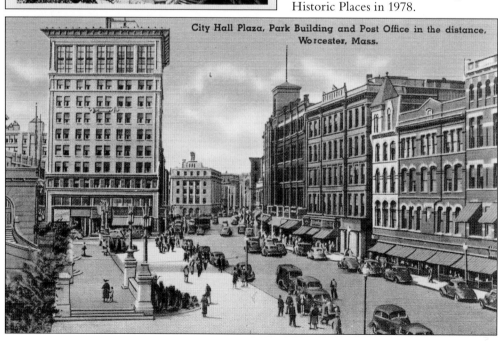

City Hall Plaza, Park Building and Post Office in the distance, Worcester, Mass.

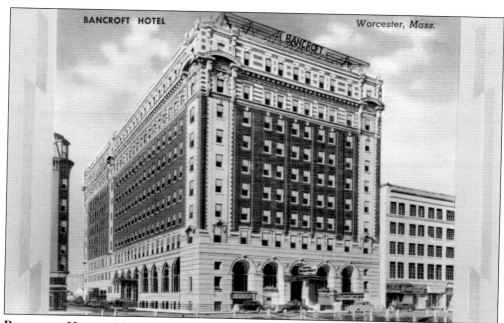

BANCROFT HOTEL, 50 FRANKLIN STREET, WORCESTER. Built in 1912 and ranked among the finest hotels in Massachusetts, the 800-room Bancroft Hotel incorporated the latest amenities to ensure its patrons' satisfaction for years to come. Its ideal location adjacent to the City Hall Plaza made it a favorite for travelers and a center for local business and social activities. The building is in the National Register of Historic Places.

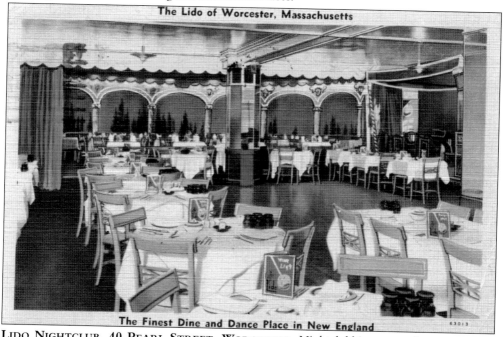

LIDO NIGHTCLUB, 40 PEARL STREET, WORCESTER. Nightclubbing was a favorite activity during the 1920s and 1930s, and in Worcester, the Lido was one of the most popular venues for dining and dancing. Its location in the center of the business district and its movie-set decor drew revelers from nearby hotels as well as local citizens enjoying a night on the town.

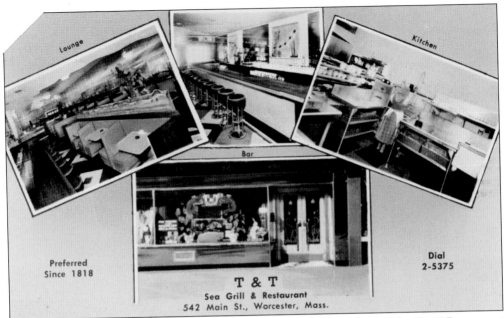

Lounge

Kitchen

Bar

Preferred
Since 1818

Dial
2-5375

T & T
Sea Grill & Restaurant
542 Main St., Worcester, Mass.

T&T RESTAURANT, 542 MAIN STREET, WORCESTER. The slogan of the T&T Restaurant was "Preferred since 1818," but it was decidedly up-to-date on this postcard. Guests were invited to view their "Stainless Steel All Electric Equipped Hot Point Most Modern Kitchen." Free parking was provided in the rear.

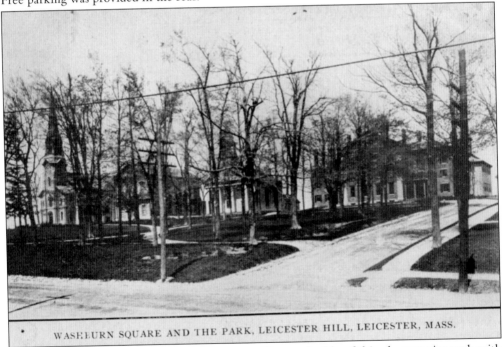

WASHBURN SQUARE AND THE PARK, LEICESTER HILL, LEICESTER, MASS.

WASHBURN SQUARE AND PARK, LEICESTER. The south side of this pleasant city park with its attractive curved pathways abutted Leicester's Main Street and provided passersby with a view of the park and the stately homes and churches surrounding it. This view from the 1930s appears to have been taken either in the spring or fall as the trees are devoid of leaves.

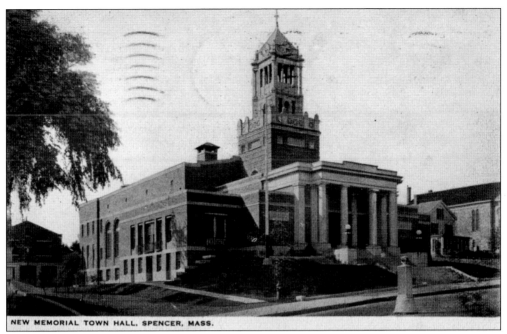

NEW MEMORIAL TOWN HALL, SPENCER, MASS.

NEW MEMORIAL TOWN HALL, SPENCER. Spencer's town hall presented an attractive colonial facade that faced Main Street and a less ornate and more utilitarian style at its rear. The writer of this card in 1937 was on her way to an alumni weekend at the University of Massachusetts in nearby Amherst, where she was looking forward to hearing a concert and attending the football game.

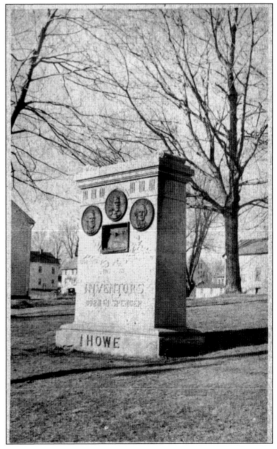

HOWE MEMORIAL, SPENCER. The Howe family of inventors ranks high among the notable residents of Spencer. William Howe developed a wooden truss system for bridge construction, and his brother Tyler invented a bedspring. Their nephew Elias Howe Jr. became the most famous following his invention of the lockstitch sewing machine. The Howes have been duly commemorated by a monument in the center of the community.

45

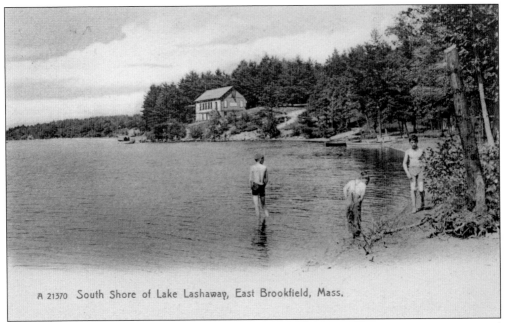

A 21370 South Shore of Lake Lashaway, East Brookfield, Mass.

LAKE LASHAWAY, EAST BROOKFIELD. Lake Lashaway has long been a favorite recreational site for residents of East Brookfield. The lake provided swimming, boating, and fishing in the summer and skating in the winter. In this c. 1920s photograph, three boys are sampling the lake's waters. The posture of the boy farthest from the shore might indicate that the water was still quite cold when this photograph was taken.

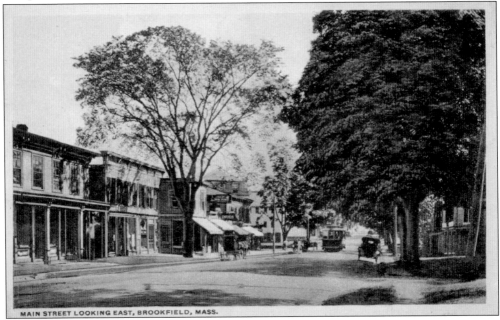

MAIN STREET LOOKING EAST, BROOKFIELD, MASS.

MAIN STREET LOOKING EAST, BROOKFIELD. Sidewalks and curbs appear to have been installed only on the left side of Main Street, with pedestrians on the right side using the gravel path. The gradual transition from horse-drawn to motorized vehicles in the early years of the 20th century is evident, as vehicles of both types can be seen in this photograph.

46

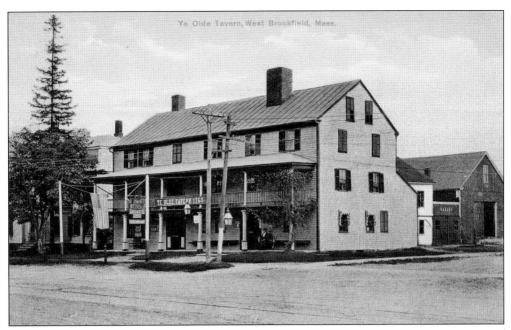

YE OLDE TAVERN, WEST BROOKFIELD. Built in 1760, Ye Olde Tavern has been a center of hospitality for more than 250 years. Originally, it was a stagecoach stop for persons traveling between Boston, Albany, and points west. George Washington stayed here in 1769, as did John Adams in 1799 and 1804. Other early guests included Revolutionary War hero General Lafayette and Daniel Shays, the famous leader of Shays' Rebellion.

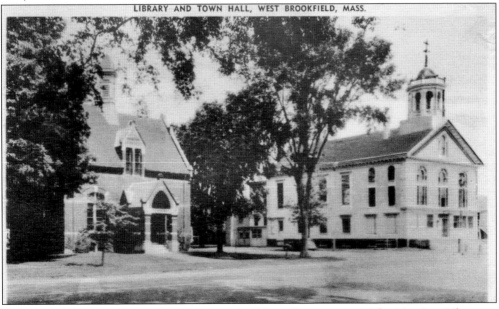

LIBRARY AND TOWN HALL, MAIN STREET, WEST BROOKFIELD. The Merriam Library at the left of this photograph was built in 1880 with funding provided by Charles Merriam, a West Brookfield native and publisher of the *Merriam-Webster Unabridged Dictionary*. Its appearance has changed little over the past 130 years. Similarly, West Brookfield's beautiful town hall, built in 1859, also maintains its original appearance.

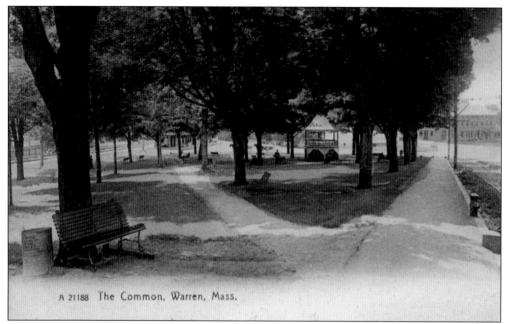

A 21188 The Common, Warren, Mass.

THE COMMON, WARREN. The village green in many small towns along Route 20 was a pleasant place for local citizens to gather for a chat with neighbors or to simply relax and enjoy the peaceful surroundings. No doubt the gazebo in the distance was the focal point for many community events including band concerts on summer evenings.

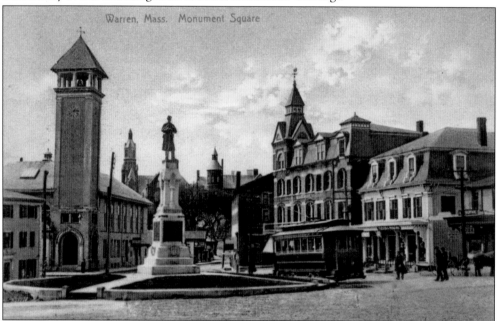

Warren, Mass. Monument Square

MONUMENT SQUARE, WARREN. Warren had the appearance of a medieval European city during the 1920s. Monument Square, in the center of the business district, was surrounded by buildings with imposing facades that were topped by spires, all giving the impression of authority. The centerpiece of the square was a large statue honoring the "Soldiers and Sailors who served in the War of Rebellion, 1861–1865."

Three

THE HARTFORD TURNPIKE

In 1933, a significant alteration of Historic Route 20 took place in Massachusetts that turned out to be a precursor to modern highway design. Route 20 in Worcester became one of the first highways in the country to utilize a bypass route around the metropolitan area rather than forcing motorists to drive directly through the city. This less congested and faster system has become commonplace, especially within the interstate highway system.

A few miles northwest of Shrewsbury, the new road, called both the Hartford Turnpike and the Southwest Cutoff, veered away from original Route 20. The approximately 40-mile route bypassed Shrewsbury, Worcester, and several towns lying to the west. When first constructed, the Hartford Turnpike coursed mostly through farmland, but over the years urban sprawl has claimed much of the open space. The road touched the southernmost shore of Lake Quinsigamond and went directly to Sturbridge and its famous historical site, Old Sturbridge Village, one of the country's largest and most popular living history museums.

Old Sturbridge Village celebrates life in New England during the first half of the 19th century. The idea was conceived by George B. Wells, grandson of George Washington Wells, founder of the American Optical Company. Wells's father and two uncles had founded the Wells Historical Museum to display their large collections of antique furniture and timepieces. Rather than duplicate other museums of the day, Wells carried their plan to the next level by creating a working village and farm where artifacts could be displayed in actual use. Planning for the village began in 1936, and soon farmland was purchased. A curator was hired to catalog the historical artifacts, and a search for authentic New England buildings was undertaken. By 1941, several of the village's buildings had been located and moved to the farm, but further development was curtailed during World War II. Work resumed following the war, and Old Sturbridge Village opened to the public on June 8, 1946. It has been a favorite attraction for travelers on Route 20 ever since.

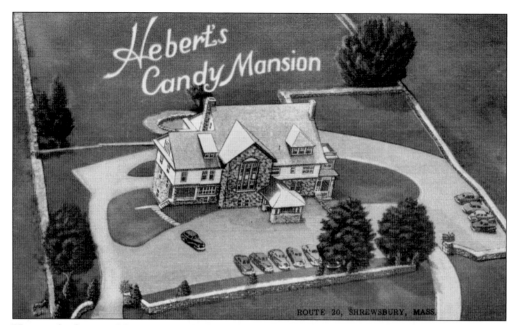

HEBERT'S CANDY MANSION, 575 HARTFORD TURNPIKE, SHREWSBURY. This large Tudor house occupied its present location when Route 20 was designated a federal highway, but it did not assume its later significance until it was purchased by Frederick Hebert in 1946. Hebert, founder of Hebert Candies in 1917, chose this location to be the headquarters of his company. Hebert's Candy Mansion is recognized as "America's First Roadside Candy Store."

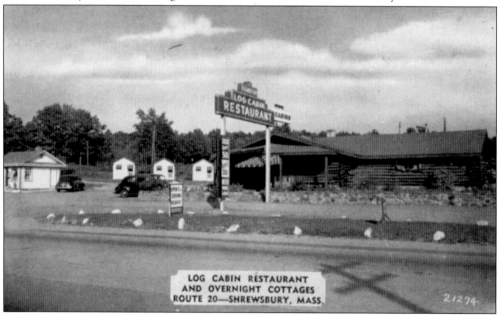

LOG CABIN RESTAURANT, HARTFORD PIKE, SHREWSBURY. This Route 20 roadhouse provided Western ranch-style hospitality with its log walls and timbered ceiling. The rustic dining room with its warm fire was an inviting attraction. The adjoining cottages had private bathrooms with hot and cold running water. Specialties of the house included spaghetti, chicken, and steak dinners with prices ranging from 35¢ to $1.

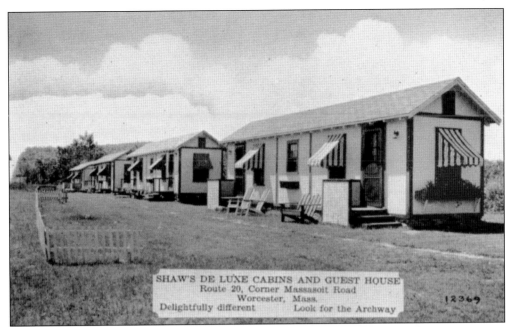

SHAW'S DELUXE CABINS AND GUEST HOUSE, CORNER OF ROUTE 20 MASSASOIT ROAD, WORCESTER. The owners advertised this small cabin camp on the Hartford Turnpike as being "Delightfully Different," but given the austere, treeless setting, it is difficult to see how that could have been the case.

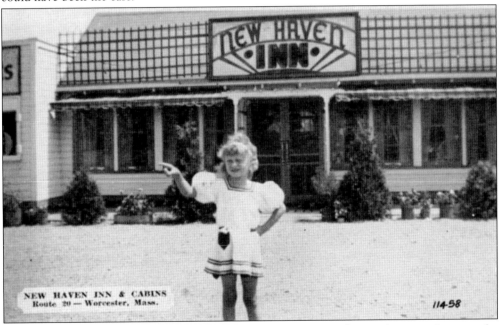

NEW HAVEN INN AND CABINS, ROUTE 20, WORCESTER. If attracting attention was the objective of this advertising postcard, the owners of the New Haven Inn probably succeeded by featuring this cute little girl, possibly the owner's daughter, in the photograph. There is no further information on the card to indicate the restaurant's address or what she might be pointing to.

SANDWICH HOUSE, JUNCTION OF ROUTE 12 AND 20, AUBURN. The unique menu at this restaurant featured "Lawrence Welk's Squeezeburger and Accordion Fries." Special breakfasts, quick lunches, full course dinners, midnight snacks, and "a meal in a sandwich" were also featured. Someone driving a shiny Chrysler "Woodie" convertible was patronizing the restaurant in the 1940s.

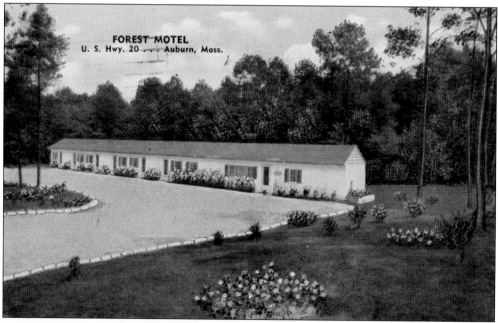

FOREST MOTEL, ROUTE 20, AUBURN. Typical of most motels of the day, the Forest Motel proclaimed itself to be one of New England's most modern, with plenty of hot water and all tile showers and toilets. The owners obviously placed considerable effort into creating an attractive landscape with several flower beds and stone borders along the driveway.

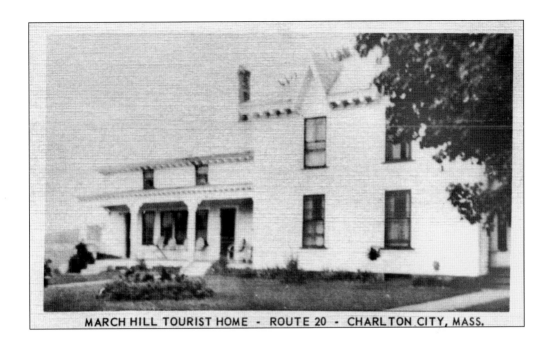

MARCH HILL TOURIST HOME - ROUTE 20 - CHARLTON CITY, MASS.

MARCH HILL TOURIST HOME AND BLUE BIRD TOURIST HOME, CHARLTON CITY. The primary function of the two large farmhouses shown on these cards no doubt was to serve the needs of the owners' families, but as was common during the early years of Route 20, extra rooms frequently were made available for travelers as a means of supplementing the family income. Typically, the accommodations were simply a bedroom with guests sharing a bathroom with the owners. Both cards are undated, but the top photograph, March Hill, appears to be from the 1920s or 1930s, and the lower card, the Blue Bird, appears to be from the 1940s.

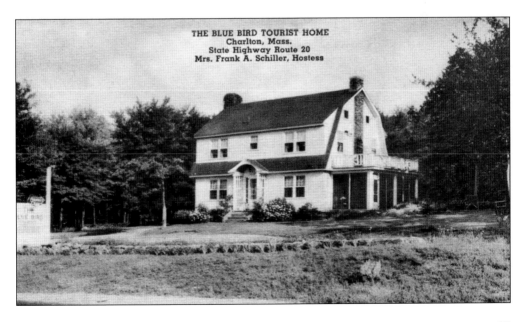

THE BLUE BIRD TOURIST HOME
Charlton, Mass.
State Highway Route 20
Mrs. Frank A. Schiller, Hostess

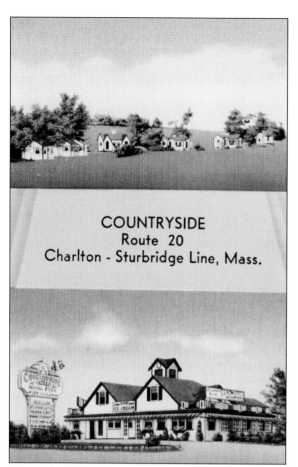

COUNTRYSIDE, ROUTE 20, CHARLTON–STURBRIDGE LINE. When this card was published in the 1930s, the Countryside was a large, attractive restaurant with a menu featuring fountain service, sandwiches, fried clams, and complete dinners. Overnight guests were accommodated in the tourist camp, which consisted of 10 completely modern cabins in a unique setting. The upper half of the card shows the "unique setting" to be the adjoining pasture.

THE BLUE CHALET RESTAURANT, STURBRIDGE. Pictured is another roadside restaurant and tourist camp on Route 20. The sign in front told motorists that "sea foods, steaks, chops, and great lunches" were available. The automobile in the photograph indicates that this was taken during the 1930s.

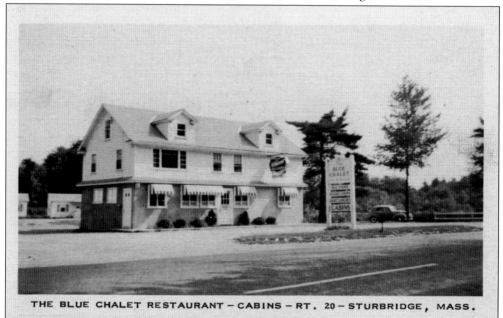

THE BLUE CHALET RESTAURANT – CABINS – RT. 20 – STURBRIDGE, MASS.

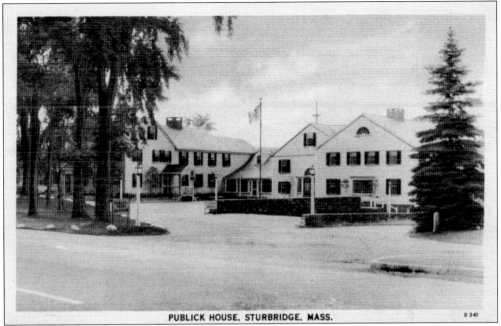

PUBLICK HOUSE, 277 MAIN STREET, STURBRIDGE. Col. Ebenezer Crafts founded the Publick House on Sturbridge Common in 1771. Like most early inns, it was originally a stagecoach stop. Unlike most of its contemporaries, it has survived for almost 250 years. The favorable location on the Boston Post Road was a definite advantage, and Colonel Crafts was renown for his hospitality, a tradition that survived through subsequent owners.

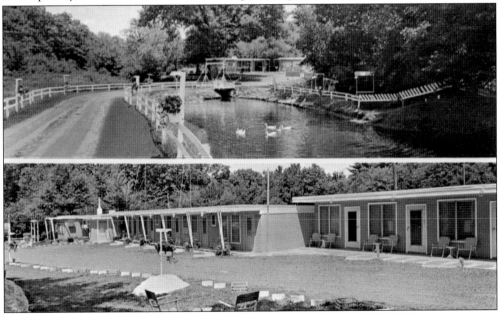

VILLAGE MOTEL, ROUTE 20, STURBRIDGE. An evolving style in motel architecture is evident in this example. It was described on the back of the card as a "most relaxing and unique motel that is so very private, nestled into the hills of New England next to historic Old Sturbridge Village." Possibly the duck pond and the lawn chairs contributed to the relaxing atmosphere.

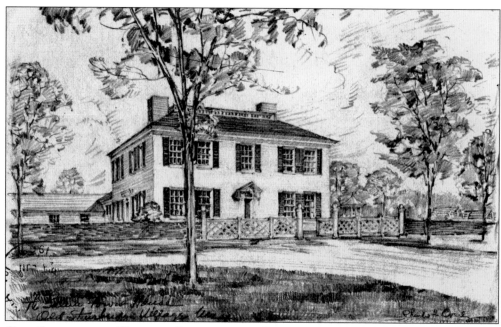

OLD STURBRIDGE VILLAGE, JUNCTION OF ROUTES 20 AND 15, STURBRIDGE. Old Sturbridge Village is a reconstructed Yankee community designed to show life in New England during the period between 1790 and 1830. When these cards were printed, it was comprised of 30 exhibition buildings built around a typical village common. All were moved to the site from various New England locations. They include homes, craft shops, stores, a school, a meetinghouse, and farm buildings. The site encompasses approximately 80 acres and is New England's largest living museum of history. The Salem Towne House (top photograph) was built in 1796. It is the centerpiece of the common and has been called the "Crown Jewel" of the museum. The Mashapaug House (below) also sits on the common. It is distinguished by its weathered red clapboard exterior.

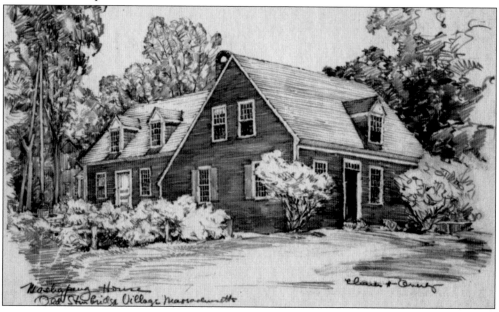

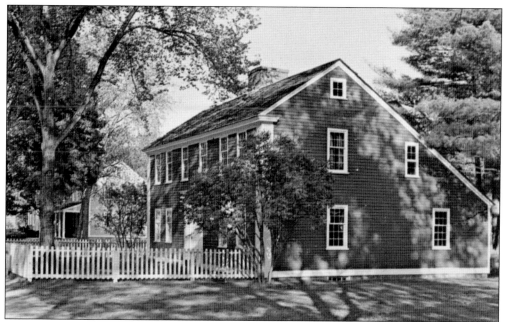

THE SOLOMON RICHARDSON HOUSE, OLD STURBRIDGE VILLAGE, STURBRIDGE. Built around 1748 in Podunk, Massachusetts, near present-day East Brookfield, this house is an example of New England saltbox-style housing, with its two-story front facade and long sloping roof at the rear. The balanced and symmetrical windows and doors and the large central chimney added character to the design and contributed to the style's popularity.

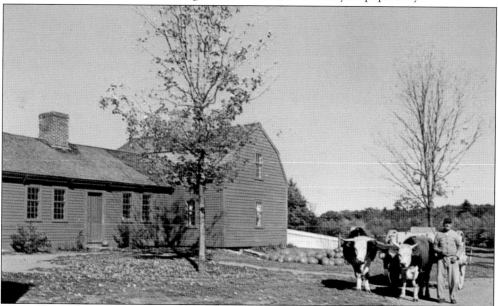

THE PLINY FREEMAN FARMHOUSE, OLD STURBRIDGE VILLAGE, STURBRIDGE. Pliny Freeman, a Sturbridge farmer, bought this house and 35 acres of land for $381 at auction in 1828. The original farmhouse on the left was built in 1801. He and his family lived on the property for 23 years, during which time he made several improvements, including the large kitchen ell at the right of the building.

WOODEN INDIAN, OLD STURBRIDGE VILLAGE. This wooden Indian guarded the entrance of Miner Grant's General Store. From its porch, visitors looked down the green past the houses that surrounded it toward the village meetinghouse. The store, built in the late 1700s, was originally located in Stafford, Connecticut. It contains displays of period merchandise, an early post office, and an ambiance designed to allow visitors to relive the past.

PARK HAVEN MOTEL, ONE MILE WEST OF OLD STURBRIDGE VILLAGE, FISKDALE. The nearness of this farm to Old Sturbridge Village probably motivated the owners to add a row of motel units at the rear of the barnyard for tourists visiting the museum. Normal farming activities did not appear to have been effected. Barns and other outbuildings remain, and the fields and garden plots were still being cultivated.

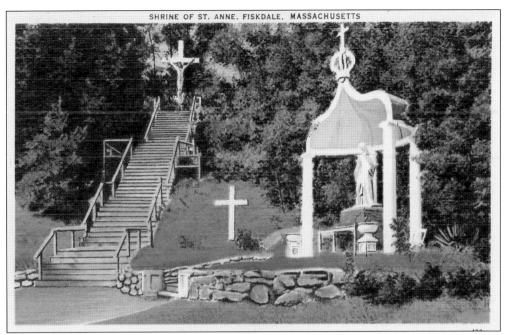

St. Anne's Shrine, 16 Church Street (Off Route 20), Fiskdale. There is not universal agreement concerning the origin of this shrine. One version states that in 1879, a pastor in failing health pledged that if he recovered he would build a shrine in honor of St. Anne. He did, in fact, recover, and fulfilled his promise. A second version attributes the origin to a parishioner in 1888, who by virtue of a miracle was cured of dropsy and thus built the shrine. Irrespective of the exact origin, for more than 110 years the faithful have come to this holy place seeking solace and peace from God through the intercession of St. Anne. The stairway to the shrine is shown in the top postcard, and the outdoor chapel is shown below.

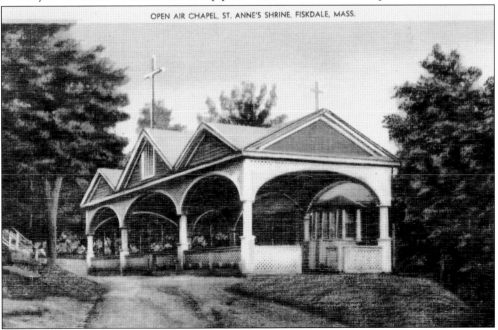

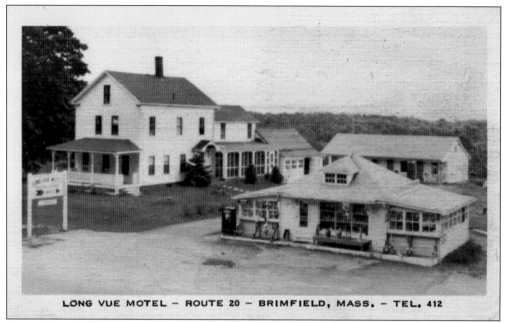

LONG VUE MOTEL – ROUTE 20 – BRIMFIELD, MASS. – TEL. 412

LONG VUE MOTEL, BRIMFIELD. The front yard of this farmstead was converted into a tourist court to take advantage of traffic on Route 20. The farmhouse served as the office and some of the outbuildings were remodeled for motel units and a general store. The writer of the postcard reported that they were spending the night here after following Highway 20 from Albany.

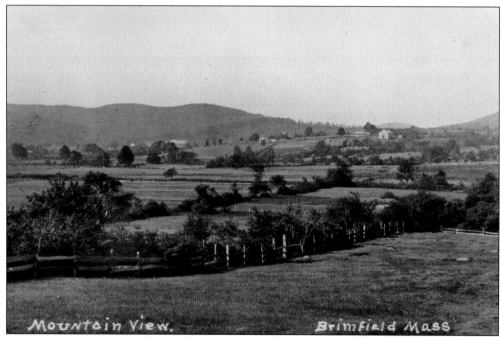

Mountain View. Brimfield Mass

MOUNTAIN VIEW, BRIMFIELD. As Route 20 crossed central Massachusetts, the views from the road became more bucolic. The area surrounding Brimfield was particularly attractive, predominated by rolling hills and small farms with larger mountains in the distance.

Four

SPRINGFIELD AREA

Original Route 20 through Worcester, and the Hartford Turnpike Bypass merged a short distance west of Brimfield, Massachusetts, and the roads continued west as one road, passing through Palmer and North Wilbraham before reaching Springfield. The areas of western Massachusetts on both sides of the Connecticut River have long been among the most productive agricultural regions of New England. Early settlers knew the value of fertile land and abundance of water. Those with foresight recognized the value of the river as a future trade route. By the late 1700s, considerable growth in the area had occurred, making Springfield an important commercial center. As the gateway to western Massachusetts's Berkshire Mountains, it became a destination for tourists. Stagecoaches, railroads, and eventually highways brought visitors to Springfield. Several hotels and restaurants opened, and as automobile travel became more popular, tourist homes, cabin camps, early motels, and service stations were built to accommodate the traveling public. Until the arrival of the interstate highway system in the 1950s, Route 20 was the primary east-west highway serving Springfield and communities on both sides of the river.

Bridging the Connecticut River was a difficult task. The first two bridges, built in 1805 and 1814 respectively, were both destroyed by ice and flooding after only a few years. The third bridge functioned effectively until the Memorial Bridge, which extended from the center of Springfield's business district, opened in 1922. Springfield's North End Bridge opened in 1925. The Memorial Bridge was the designated crossing for Route 20 for four decades, although many motorists—especially those who wished to visit more of Springfield's downtown hotels, restaurants, and retail establishments—drove north on Main Street and crossed the North End Bridge. Both the Memorial and the North End Bridges contributed to the evolution of automobile and truck traffic on Route 20. Regardless of the route chosen, the roads merged in West Springfield before proceeding on to Westfield, the most westerly Route 20 community in the Springfield Standard Metropolitan Area and a significant city in its own right.

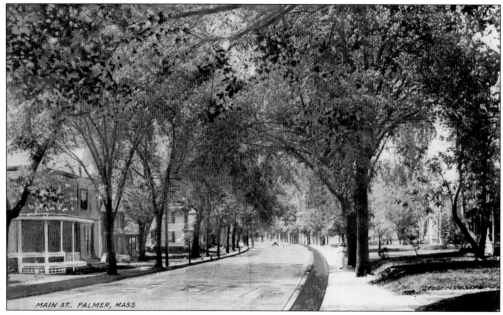

MAIN STREET RESIDENTIAL NEIGHBORHOOD, PALMER. Most smaller communities through which early Route 20 passed were characterized by pleasant residential neighborhoods on either side of the business district. This was especially true in Palmer, where large trees lined the street, making the drive attractive and providing shade for the houses along the way.

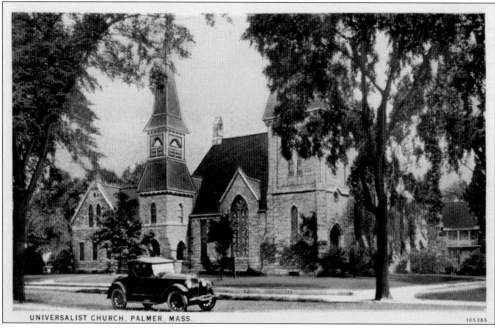

UNIVERSALIST CHURCH, CENTRAL AND PARK STREETS, PALMER. Neighborhood churches were icons in most towns, as was this one on Route 20 in Palmer. Throughout the highway's entire history, travelers have enjoyed viewing this attractive structure and surrounding grounds. The persons who mailed this card said they were having a wonderful trip. They planned to arrive in Boston the following day and then take a boat back to Philadelphia.

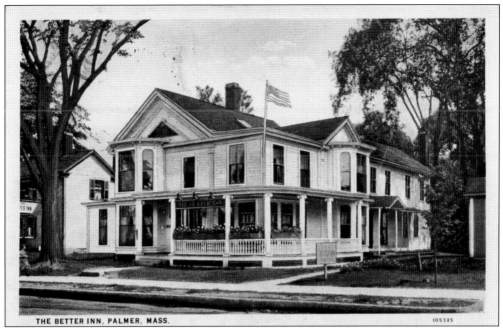

THE BETTER INN, PALMER, MASS. 105335

THE BETTER INN, PALMER. This roadside tourist home would have been hard to miss with its signs in the front yard, on the front porch, hanging from the tree in front of the house, and an American flag on the roof. The large front porch with potted plants on the railing would have been a pleasant place to relax in the evening.

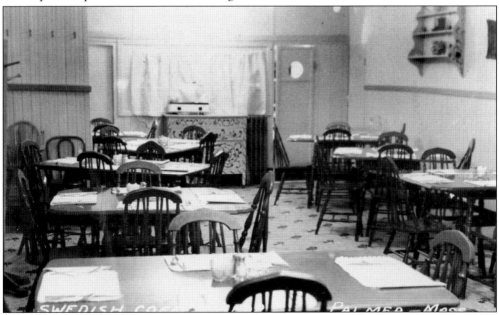

SWEDISH COFFEE SHOP, PALMER. The decor of this coffee shop reflected its Swedish heritage. The large chest in the back of the room and the shelves on the right wall were hand-painted in the Scandinavian folk-art tradition known as Rosemaling. Although the room was unoccupied when this photograph was taken, it still projected a comfortable and homey atmosphere. Note the old-fashioned hall tree on the left.

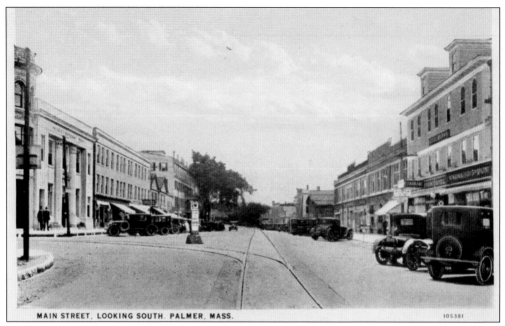

MAIN STREET, LOOKING SOUTH, PALMER, MASS.

MAIN STREET, PALMER. Automobiles were making incursions into traditional urban trolley transportation when this photograph of Palmer's Main Street was taken in the mid-1920s, around the time the street became Route 20. There were no electrical wires above the track, indicating that the trolleys were still drawn by horses.

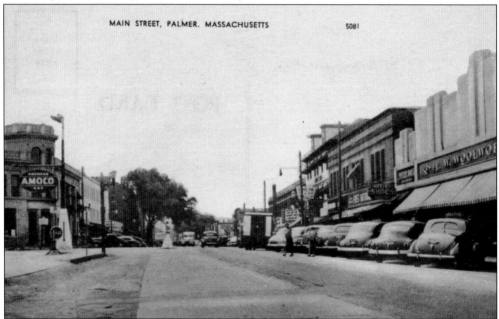

MAIN STREET, PALMER. MASSACHUSETTS

MAIN STREET, PALMER. This photograph was taken approximately 20 years after the previous photograph. The theater on the right side of street was showing *The Bishop's Wife*, starring Cary Grant and Loretta Young. Although the movie was released in 1947, all the cars on the street are from the 1930s and early 1940s. This was due to the moratorium on automobile production during World War II.

HOUSE OF SHAKERS AND OLD SALTS, 3157 BOSTON ROAD, NORTH WILBRAHAM. Mrs. Frederick Ruther operated this unusual business located on Route 20 not far from the Palmer city limits. Hundreds of unique salt-and-pepper shakers were on display, ranging from novelty items, cartoons, sports and political figures to fine crystal sets.

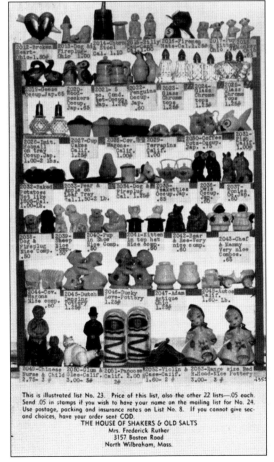

HOUSE OF SHAKERS AND OLD SALTS, NORTH WILBRAHAM. This advertising postcard is illustrated as List No. 23 in a series that showed many of the salt-and-pepper shaker sets available at this store. The price of the list was 5¢. The previous 22 lists also were available at 5¢ each, and customers could send 5¢ in postage stamps to place their name on the mailing list for No. 24.

65

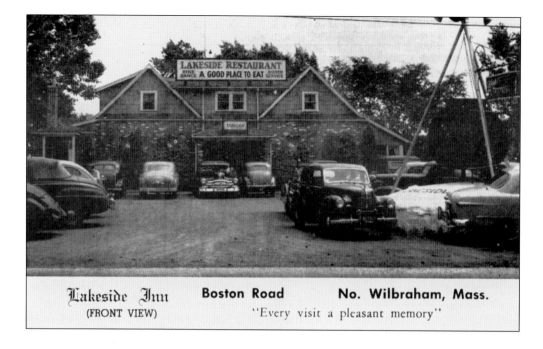

Lakeside Inn Boston Road No. Wilbraham, Mass.
(FRONT VIEW) "Every visit a pleasant memory"

LAKESIDE INN, BOSTON ROAD, NORTH WILBRAHAM. The Lakeside Inn on Nine Mile Pond west of North Wilbraham was a popular destination in the 1930s and 1940s. Its slogan was "Every visit a pleasant memory," and the full parking lot in the top photograph seems to verify that boast. The photograph below illustrates the inn as a venue to picnic, swim, sail, dine, and dance. The establishment also had a beer garden, which probably did not lack for patronage. A small raft, anchored in the lake, was used for swimming and diving and also as a place to relax and bask in the sun.

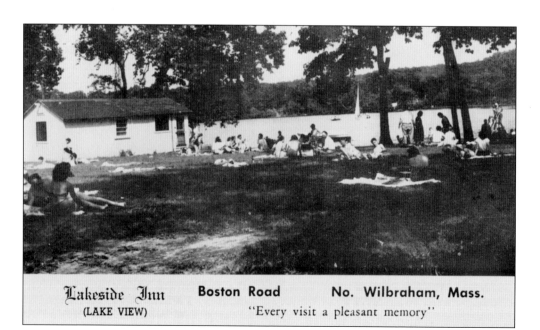

Lakeside Inn Boston Road No. Wilbraham, Mass.
(LAKE VIEW) "Every visit a pleasant memory"

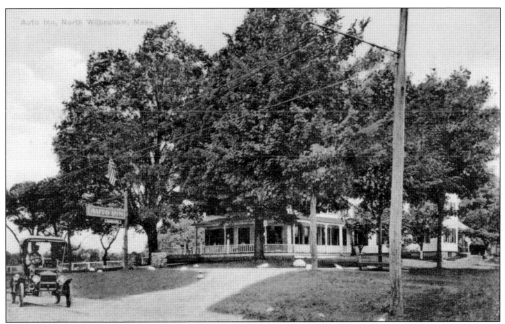

WILBRAHAM AUTO INN, NORTH WILBRAHAM. The Wilbraham Auto Inn was located on Nine Mile Pond. The automobile indicates that this photograph predates Route 20, but the inn was a roadside fixture throughout the early years of the highway. It eventually stopped offering lodging but continued as a tavern and dancehall for three decades after the Boston Post Road was designated Route 20. The inn burned down in the 1950s.

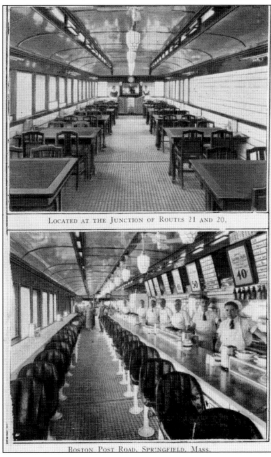

LOCATED AT THE JUNCTION OF ROUTES 21 AND 20.

BOSTON POST ROAD, SPRINGFIELD, MASS.

SAM'S DINER, INC., BOSTON POST ROAD, SPRINGFIELD. Sam's Diner and Route 20 were both established in 1926. Its location at the junction of Route 20 and Massachusetts Route 21 assured plenty of traffic. Self-proclaimed to be the largest and most completely equipped diner in New England, it provided counter service areas plus table seating and specialized in home cooking. Sam's Diner never closed, and public inspection was invited.

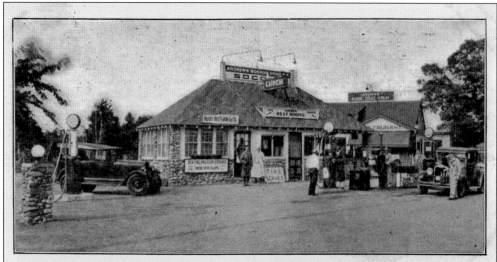

ANDREW'S ROSE TREE INN AND SERVICE STATION
Boston Road and Parker St. -:- Springfield, Mass.

On the Four Corners - Main Highway to Boston

ANDREW'S ROSE TREE INN AND SERVICE STATION, BOSTON ROAD AND PARKER STREET, SPRINGFIELD. This establishment either had plenty of customers or plenty of help, as at least seven people can be counted in the service area in front of the building. In keeping with its Massachusetts roots, the restaurant was featuring New England Clam Chowder and fresh open clams on the day this photograph was taken.

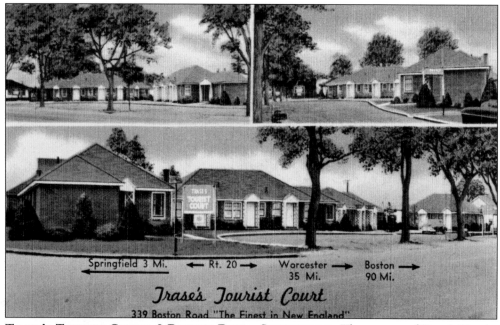

TRASE'S TOURIST COURT, 9 BOSTON ROAD, SPRINGFIELD. The owners of Trase's Tourist Court left no doubt about its location and distance from several cities on Route 20. The front of the card proclaims it to be the "finest in New England," and the back says it has the "finest in accommodations, 42 modern units—Clean—Steam Heated—Good Beds."

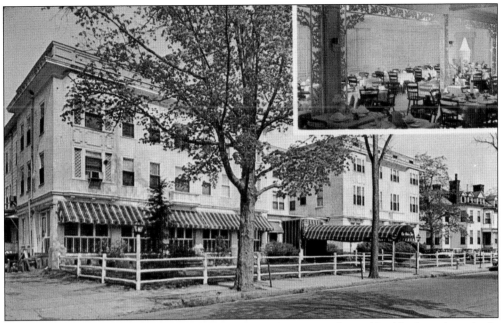

THE OAKS INN, ROUTE 20, SPRINGFIELD. The Oaks Inn proclaimed itself to be a charmingly restored homestead and a haven for gourmets. The menu featured "three-inch" steak, prime rib, lobster dinners, and a full liquor license.

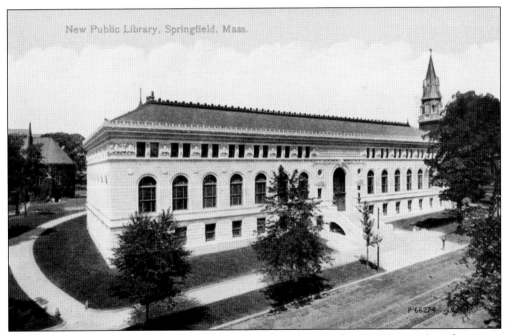

PUBLIC LIBRARY, SPRINGFIELD. After outgrowing three earlier buildings, plans for a new library were begun in 1892. Over several years, $155,000 was raised from local citizens and a $260,000 gift from Andrew Carnegie in 1905 enabled the building of the library pictured on this postcard. Construction began in 1909, and the library opened to the public on January 10, 1912. The library is in the National Register of Historic Places.

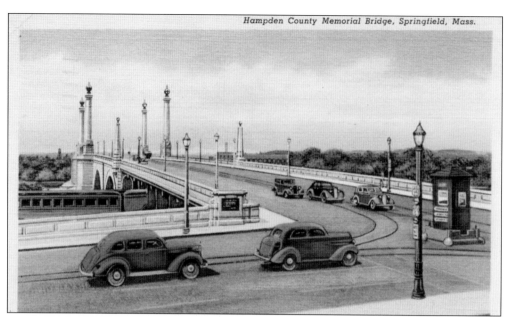

MEMORIAL BRIDGE, SPRINGFIELD. Memorial Bridge opened in 1922. It was the original Route 20 crossing of the Connecticut River and the route followed by travelers heading west. Those wishing to spend time in downtown Springfield typically continued north on Main Street, as shown in the following cards. The Memorial Bridge's four towers each display a plaque honoring the original colonists and veterans of the Revolutionary War, Civil War, and foreign wars.

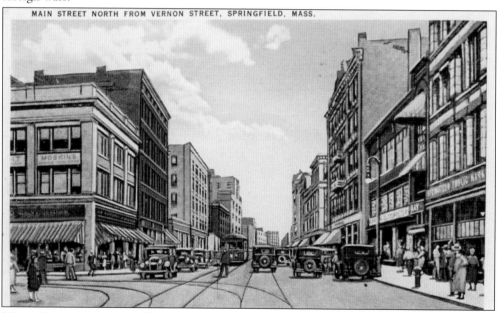

MAIN STREET NORTH FROM VERNON STREET, SPRINGFIELD, MASS.

MAIN STREET LOOKING NORTH, SPRINGFIELD. Route 20 motorists who opted for a closer view of Springfield followed Main Street through the business district before crossing the river on the North End Bridge. This view of Main Street shows the necessity of caution, as cars, trolleys, and pedestrians all used the street simultaneously. No traffic signals or police officers are evident to direct traffic.

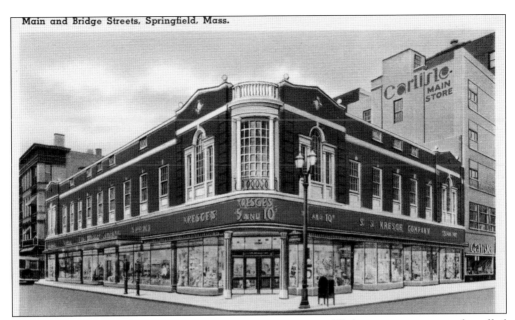

KRESGE'S, MAIN AND BRIDGE STREETS, SPRINGFIELD. Variety stores, commonly called "5-and-10-cent stores," were a fixture on almost every main street across the country in the 1930s. Typically, these stores carried inexpensive household items, such as paper products, cleaning and sewing supplies, some clothing items, and school supplies. Most also contained a candy counter. Sebastian Kresge founded the company in 1899. In 1977, it became Kmart.

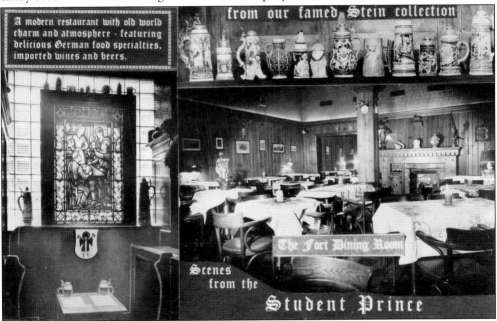

STUDENT PRINCE RESTAURANT, 8 FORT STREET, SPRINGFIELD. Continuing north, Route 20 travelers passed the Student Prince restaurant at the corner of Main and Fort Streets. This German restaurant was established in 1935 and was well-known for its fine dining and congenial atmosphere. While dining and enjoying fine imported beer or wine, guests could view the restaurant's large collection of antique steins and the beautiful stained-glass windows.

HOTEL WORTHY, MAIN AND WORTHINGTON STREETS, SPRINGFIELD. Built in 1895 and located in the heart of downtown Springfield, the Hotel Worthy was both a stopping point for travelers and a venue for social and commercial activities for the local population. Throughout much of the early 20th century, the Worthy was considered to be Springfield's finest hotel. In 1983, the building was placed in the National Register of Historic Places.

COLONIAL DINING ROOM, HOTEL WORTHY, SPRINGFIELD. The back of this postcard describes this restaurant in superlatives. It claimed to have the "pleasantest" and best-ventilated dining room in Springfield, serving only the choicest food products. The food was cooked right and served right, and the prices were moderate. Filtrated water from the Berkshires cooled with hygienic ice was used exclusively: "Both pure— that's sure."

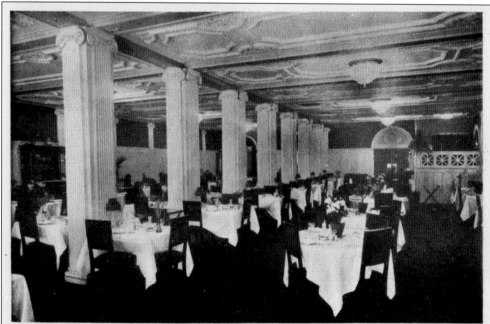

COLONIAL DINING ROOM OF HOTEL WORTHY, SPRINGFIELD, MASS. TIME TRIED AND TABLE TESTED. (See other side.)

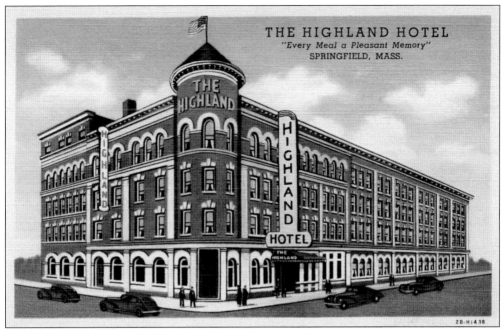

HIGHLAND HOTEL, SPRINGFIELD. The Highland Hotel provided local citizens and visitors to Springfield with all the best in 1930s-era hospitality. The restaurant boasted "every meal a pleasant memory," and guests could enjoy Muzak and a radio in every room at no extra charge. Rates ranged from $2 for a room with a detached bath to $2.50 and up for a private bath.

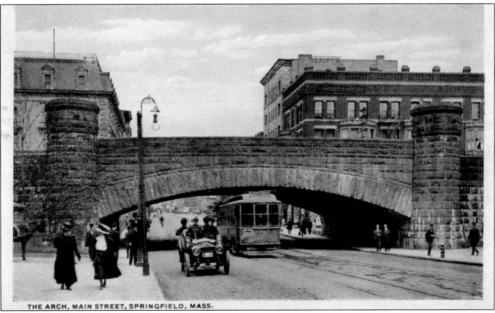

THE ARCH, MAIN STREET, SPRINGFIELD. The beautiful stone arch has been a landmark in downtown Springfield for more than a century. The first train crossed the arch in May 1890. This enabled passengers and freight on the Boston and Albany railroad to connect the terminal farther east on Arch Street with the railroad's main line along the Connecticut River, all without disrupting vehicle and pedestrian traffic on Main Street below.

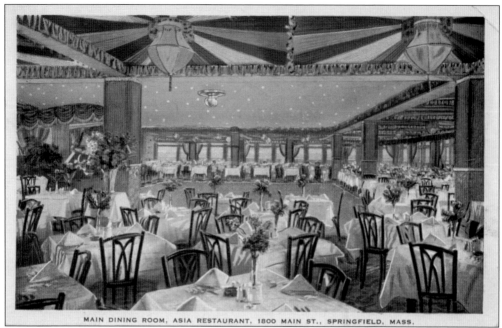

MAIN DINING ROOM, ASIA RESTAURANT, 1800 MAIN ST., SPRINGFIELD, MASS.

ASIA RESTAURANT, 1800 MAIN STREET, SPRINGFIELD. Proudly proclaiming to be the most gorgeous dining and dancing palace in New England, this ornate restaurant could seat 1,000 guests. A beautiful banquet hall was available for weddings, club meetings, and private parties. Guests were entertained by high-class vaudeville. Diners were encouraged to try the daily specials, which included luncheon for 30¢ and supper for 55¢ and up. They could also enjoy the best beer and wine.

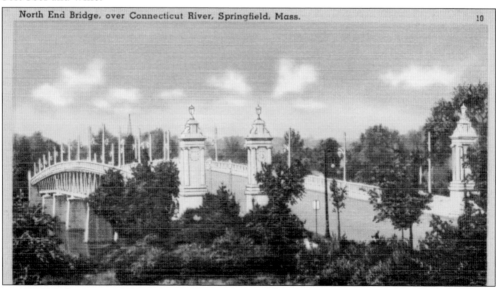

North End Bridge, over Connecticut River, Springfield, Mass. 10

NORTH END BRIDGE, SPRINGFIELD. Motorists who chose the Main Street route through downtown Springfield crossed the Connecticut River and proceeded west on the aptly named North End Bridge, where the road rejoined original Route 20 in West Springfield. In the 1960s, this bridge became the permanent river crossing following changes in the Route 20 course through Springfield.

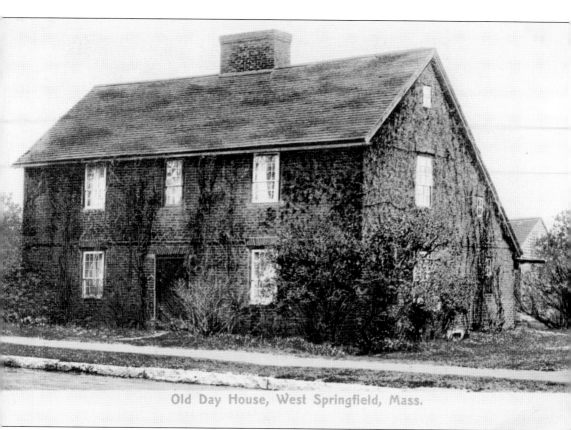

Old Day House, West Springfield, Mass.

DAY HOUSE, PARK AND HANOVER STREETS, WEST SPRINGFIELD. This house, located on Route 20 just across the North End Bridge from Springfield, has been a landmark in West Springfield for over 250 years. Josiah Day bought the site in 1746, and over a span of approximately eight years he completed the original building. A brick in the east wall is inscribed with the date of its completion in 1754. Day chose the saltbox design that was popular in the 1700s, and the house is reputed to be the oldest brick saltbox house in the United States. In 1810, a wooden addition was built at the rear of the house to accommodate Day's grandson and his family. For more than 150 years, the house was passed from generation to generation within the Day family. In 1902, the house was sold to the Ramapogue Historical Society, which recognized its historic significance and was dedicated to its preservation. The Josiah Day House and Museum is maintained in its original state, and many of the furnishings are original Day family items.

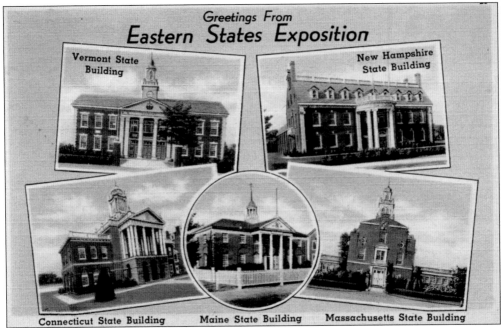

Greetings From
Eastern States Exposition

Vermont State Building

New Hampshire State Building

Connecticut State Building Maine State Building Massachusetts State Building

EASTERN STATES EXPOSITION, WEST SPRINGFIELD. In the early 1900s, Joshua Brooks organized an exposition to showcase modern farming methods and encourage more agricultural productivity. Grounds were purchased, an arena was constructed, and in 1916 the National Dairy Show was the first event at the site. Since then, buildings have been added including replicas of state houses of all six New England States. Rhode Island's replica was not completed until 1957.

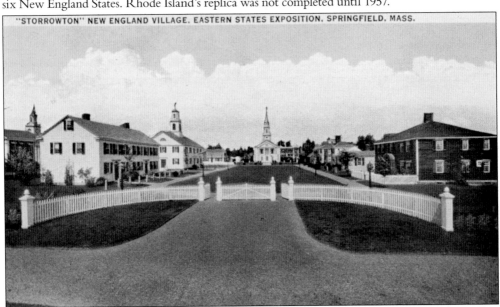

"STORROWTON" NEW ENGLAND VILLAGE. EASTERN STATES EXPOSITION. SPRINGFIELD. MASS.

STORROWTOWN VILLAGE, WEST SPRINGFIELD. This reconstructed 19th-century New England village is located on the Eastern States Exposition grounds. It was built between 1927 and 1931 through the generosity of Helen Storrow, who purchased the historic buildings and had them moved to West Springfield. Centered around a village green are the meetinghouse, tavern, schoolhouse, law office, blacksmith shop, general store, and several homes.

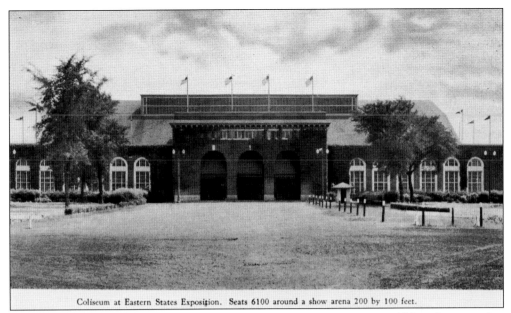

Coliseum at Eastern States Exposition. Seats 6100 around a show arena 200 by 100 feet.

COLISEUM AT EASTERN STATES EXPOSITION, WEST SPRINGFIELD. Although promotion of agriculture was the Eastern States Exposition's primary focus, visitors were attracted by multiple events held on the grounds. The ample size of the coliseum and its convenient location near Route 20 made it a popular venue for conventions, trade shows, and athletic events.

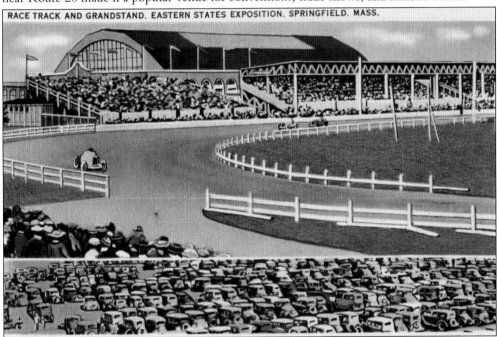

RACE TRACK AND GRANDSTAND. EASTERN STATES EXPOSITION. SPRINGFIELD. MASS.

RACE TRACK AND GRANDSTAND, EASTERN STATES EXPOSITION, WEST SPRINGFIELD. The rapidly expanding availability of automobiles in the 1920s and 1930s resulted in a concurrent rise in automobile racing. This view at the Eastern States Exposition Race Track shows a packed parking lot and grandstand filled with enthusiastic spectators. Track design and safety equipment to protect drivers and viewers were still many years in the future.

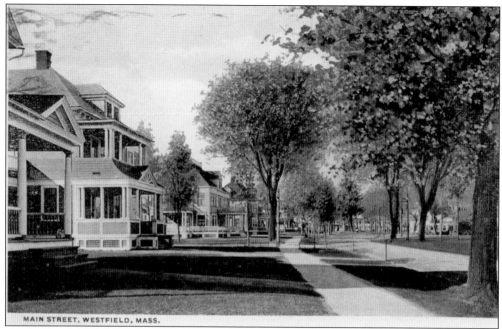

MAIN STREET, WESTFIELD, MASS.

MAIN STREET, WESTFIELD. After leaving West Springfield, Route 20 continued to Westfield, where it entered on Main Street, pictured here in the 1920s. The street was lined by stately homes and well-manicured lawns. Before the days of air-conditioning, large trees for shade, a breeze, and open front porches provided residents with relief from the summer heat.

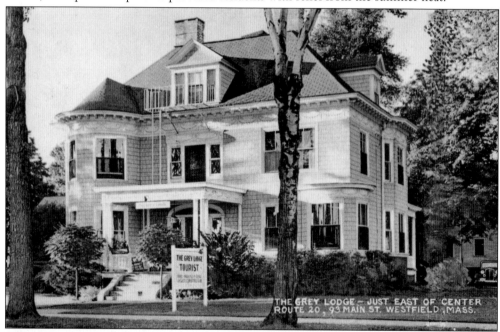

THE GREY LODGE – JUST EAST OF CENTER
ROUTE 20, 93 MAIN ST. WESTFIELD, MASS.

THE GREY LODGE, 93 MAIN STREET, WESTFIELD. A precursor of the modern bed and breakfast, this large house in Westfield opened its doors to early Route 20 tourists. Free parking, showers, a fire escape for third-floor guests, and front porch seating were offered as amenities. The car in the parking lot indicates that this photograph was taken in the early 1930s.

78

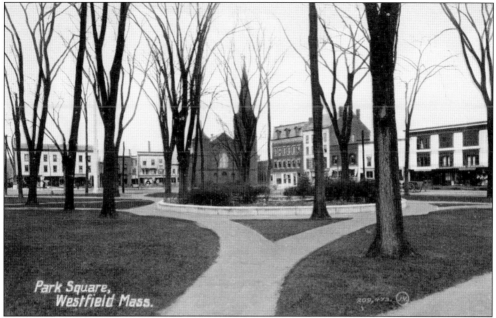

PARK SQUARE, WESTFIELD. Many New England cities that were established in the 1700s through the early 1900s had their business districts centered on the town green, which was usually a one-square block park in the center of town. Park Square in Westfield is an example of this characteristic (top and bottom photographs). The tree-shaded park is surrounded on all four sides by civic and commercial buildings, churches, and hotels, many of which are over 100 years old. Some of Westfield's most important streets, including Main and Elm Streets (which carry Route 20 traffic), extend from Park Square into Westfield's residential neighborhoods. At the turn of the 20th century, more than 50,000 buggy whips a month were produced in Westfield, earning it the title "Whip City," which it still retains.

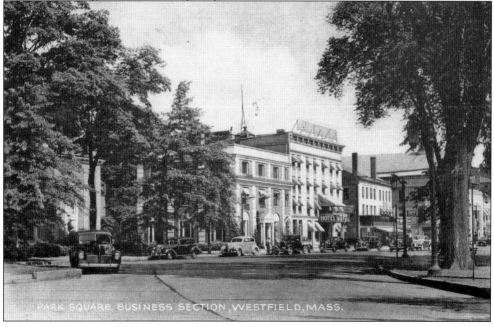

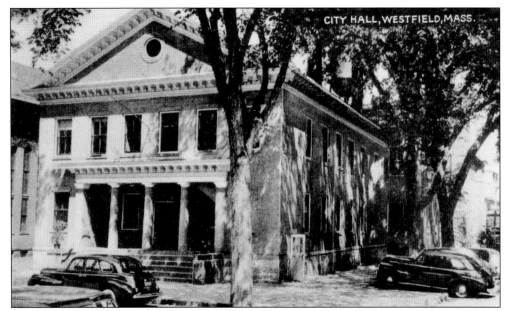

CITY HALL, PARK SQUARE, WESTFIELD. The rectangular Park Square in the center of Westfield's business district was bordered by four streets: Main Street on the north; Court Street on the south; and Broad and Elm Streets on the east and west sides, respectively. The old city hall, built in 1837 and shown in this late-1930s photograph, stood out among the many stately buildings gracing the park.

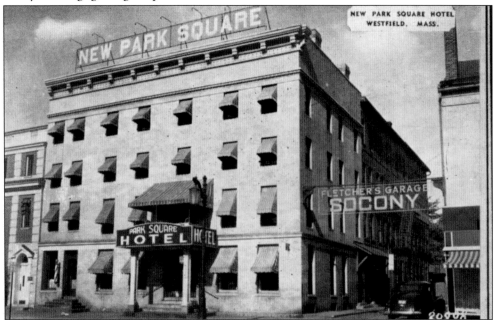

NEW PARK SQUARE HOTEL, ON THE GREEN, WESTFIELD. This hotel occupied a prominent location directly on the green during the early years of the 20th century. It was built in 1898 as a boardinghouse and later became the Westfield House Hotel. In 1914, it was remodeled and renamed the New Park Square Hotel. Fletcher's Garage originally was a stable for the hotel. The building burned down in December 1942.

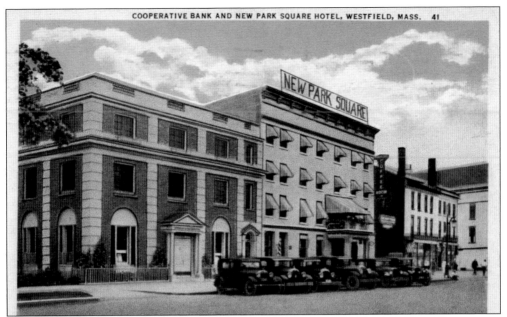

COOPERATIVE BANK AND NEW PARK SQUARE HOTEL, WESTFIELD. This photograph was taken about 10 years earlier than the postcard below. The bank and hotel, two of Westfield's prominent buildings facing the green, can be seen in both photographs. Note the unique parking pattern in front of the bank and hotel. Diagonal parking was common on many downtown streets during this period, but backing into the spaces was unusual.

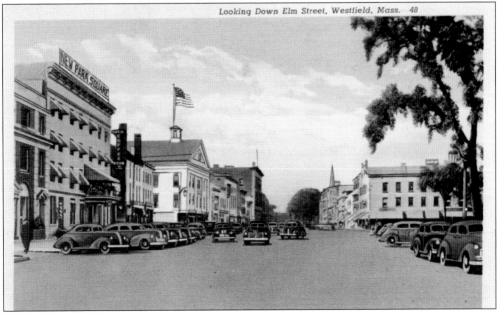

Looking Down Elm Street, Westfield, Mass. 48

ELM STREET, LOOKING NORTH FROM THE GREEN, WESTFIELD. Elm Street is a primary spoke radiating from the green in the center of Westfield. Route 20 follows Elm Street for several blocks to Franklin Street, where the road then goes west leaving the city. The direction of the cars in this photograph shows that automobile traffic circled the green in a one-way, counterclockwise direction, which continues to this day.

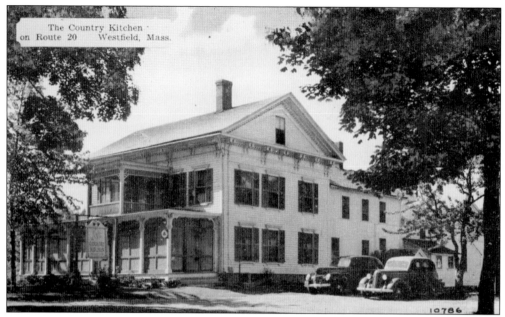

THE COUNTRY KITCHEN, WESTFIELD. Serving good food at a fair price was the objective of Marjorie Rose, the owner of this home-turned-restaurant on Russell Road (Route 20) in Westfield. At least two diners driving 1930s-era automobiles were enjoying her hospitality when this photograph was taken.

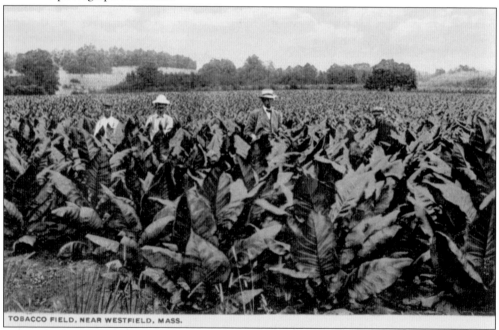

TOBACCO FIELD, WESTFIELD. The writer of this card in the 1920s was surprised by the tobacco farms surrounding Westfield. He wrote, "This is big tobacco growing country!" The tobacco produced was named Shade Grown, and only about 100 miles along the Connecticut River have soil and climate suitable for this variety. Two workers and possibly the owner are inspecting one of the Westfield's many verdant tobacco fields.

Five

JACOB'S LADDER TRAIL

Jacob's Ladder Trail, a 33-mile stretch of highway from Westfield to Lee, has been a highlight on a drive across Massachusetts for decades. The early 1900s witnessed a demand from automobile enthusiasts and merchants for a "modern" highway, specifically to accommodate the new horseless carriages. The former longed for a place to test themselves and their vehicles and the latter were looking to promote business. Jacob's Ladder Trail was the answer. Originally a simple country lane, the new road rose to a height of 2,300 feet over rugged terrain. Man and machine were challenged by the best that nature could provide. The road over the summit opened in September 1910 and was considered an engineering marvel, meriting the title "first of the great mountain crossovers." It claimed a place in transportation history, and within a few years was among the most traveled roads in the east. Jacob's Ladder Trail's ideal location on the direct route from Boston to Albany made it a logical choice for Route 20 when federal highways were designated in 1926.

For many years, communities along Jacob's Ladder Trail prospered from lumber, paper, and fabric mills built along the Westfield River, but as those industries declined, tourism rose in its place. Again, Jacob's Ladder Trail provided the answer. The beauty of the Berkshire Mountains' spectacular vistas, sparkling lakes, and forested hillsides drew motorists. Charming main streets, historic sites, and homes reflected the tastes and customs of the residents. Although the road has undergone changes over the years, the scenery remains much the same as when the road first opened.

Jacob's Ladder Trail provided activities for all tastes, and all were accessible by automobile. Jacob's Pillow Dance Theater has long been one of New England's premier cultural venues. For outdoor enthusiasts, Jacob's Ladder was the route to hunting, fishing, hiking, and canoeing. In winter, many of Massachusetts's finest skiing venues were located along the road. In recognition of its scenic beauty, quaint villages, and significant contribution to transportation in Massachusetts, Jacob's Ladder Trail was proclaimed a Massachusetts Scenic Byway in 1992.

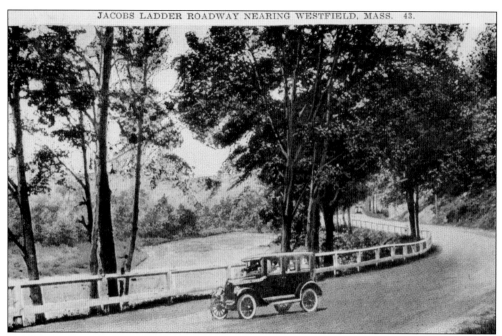

JACOB'S LADDER ROADWAY NEARING WESTFIELD. The beauty of Jacob's Ladder Trail and the desire of early travelers to see the country are both conveyed on this postcard. Mailed in July 1929, the sender was on an ambitious road trip for the time. She wrote that they had arrived in Boston, and from there would go to New York City, Washington, DC, and West Virginia before returning home to Chicago.

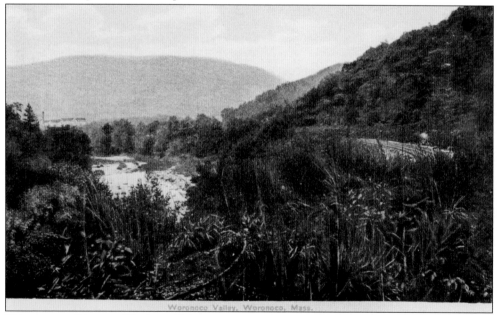

WORONOCO VALLEY. The beautiful Woronoco Valley is surrounded by three mountain ranges: Russell Mountain to the south and Mount Nero and Tekoa Mountain to the west and north. In this view, a glimpse of Route 20 can be seen in the upper right, and the Westfield River is in the center of the card. A paper mill, for which Woronoco was famous, is visible in the distance.

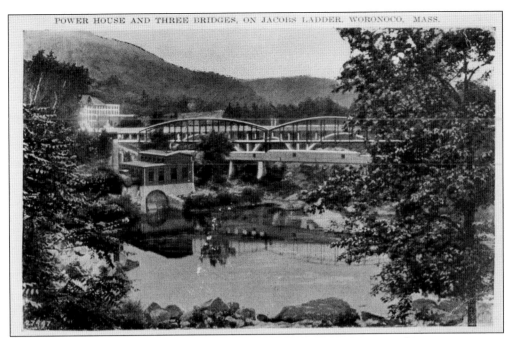

POWER HOUSE AND THREE BRIDGES, WORONOCO. The community of Woronoco was an industrial section of Russell, Massachusetts, west of Westfield. It originated as a model company town through the efforts of Horace Moses, owner of the Strathmore Paper Mill, which was noted for its production of distinctive paper products. The community consisted of schools, civic buildings, churches, and quality houses for his workers.

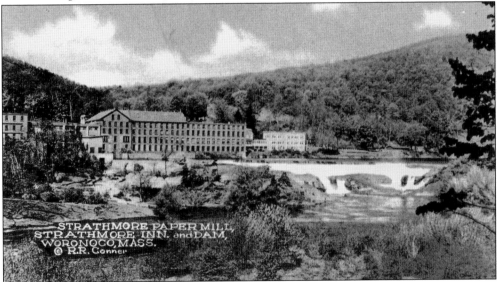

STRATHMORE PAPER MILL AND STRATHMORE INN, WORONOCO. The Strathmore Paper Company flourished throughout most of the 20th century. The model company town included the Strathmore Inn, where business, social activities, and visitors to the community could be accommodated in comfort. Horace Moses, a recognized social engineer, is credited with cofounding Junior Achievement, the world's largest organization dedicated to teaching students about entrepreneurism, workforce readiness, and responsibility to their communities.

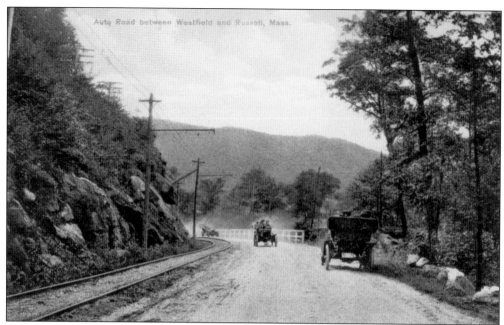

AUTOMOBILE ROAD BETWEEN WESTFIELD AND RUSSELL. Early engineering and technological progress is evident in this photograph of Jacob's Ladder Trail, a short distance west of Westfield. The face of the mountain has been recontoured to provide a flat road surface for both the highway and the adjacent trolley tracks connecting Springfield and Huntington. As shown by the telephone poles, electrical services were being brought to more rural communities.

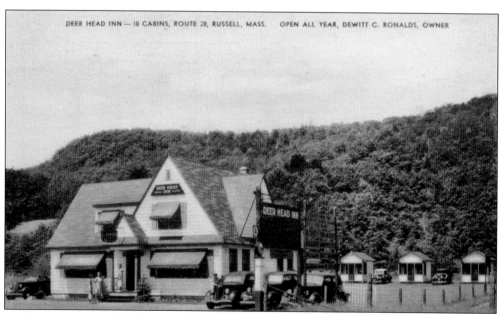

DEER HEAD INN, RUSSELL. The Deer Head Inn was a typical roadhouse where patrons could stop for a drink or a meal and travelers on Route 20 could rent a cabin for the night. Business appears to have been good on the day this photograph was taken. Several cars were in the parking lot and at least two were beside the cabins. All the cars are from the 1930s.

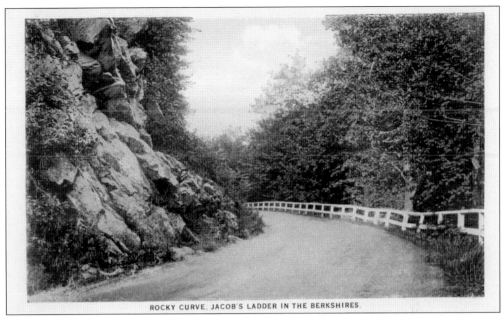

ROCKY CURVE, JACOB'S LADDER IN THE BERKSHIRES.

ROCKY CURVE ON JACOB'S LADDER. Jacob's Ladder represented a significant advance in highway engineering when it opened in 1910. Most roads of the day followed the contours of the land over hill and dale. A roadbed suitable for crossing the Berkshire summit by car required considerable modification of the landscape. This photograph shows that much rock had been removed to create a flat road surface and an acceptable incline.

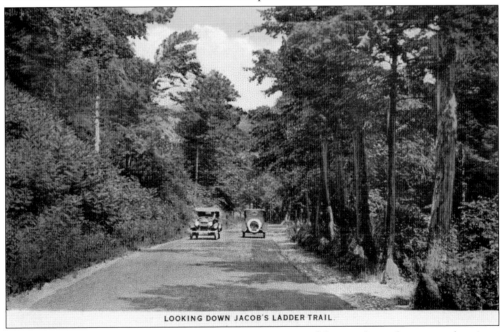

LOOKING DOWN JACOB'S LADDER TRAIL.

LOOKING DOWN JACOB'S LADDER TRAIL. Every season of the year brought spectacular views to motorists on Jacob's Ladder Trail. Travelers going both east and west were treated to unique vistas around every curve, an experience no doubt being enjoyed by the occupants of these two automobiles in the late 1920s.

Cold Springs Cabins
Located on Rte. 20 at Huntington, Mass.
Phone 2291

3/656

COLD SPRINGS CABINS, HUNTINGTON. The popularity of fishing in the Berkshires was evident from the legend on the back of this card, which shows a rustic 1940s tourist court on Route 20. The proprietors stated, "We're always happy to furnish guests with information about the good fishing spots and the surrounding countryside."

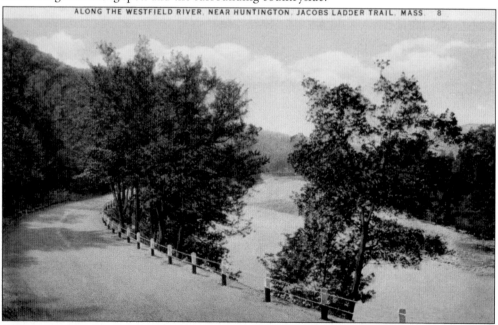

WESTFIELD RIVER FROM JACOB'S LADDER TRAIL. This scene illustrates the practice of early road builders to take advantage of naturally occurring topographical features whenever possible in planning the road's course. The placid surface of the Westfield River indicates that the gradient in this section of Jacob's Ladder Trail was relatively flat, thus greatly reducing the effort required to create a smooth roadbed.

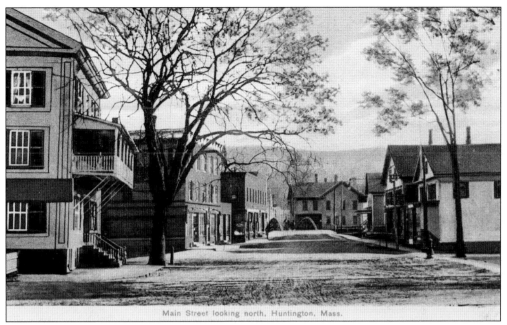

Main Street looking north, Huntington, Mass.

MAIN STREET, HUNTINGTON. Huntington was a prototypical Berkshire village when this early 1920s photograph was taken. Possibly it was early in the morning or a Sunday, as there is not a pedestrian or vehicle on the street. The bridge over the Westfield River can be seen in the distance.

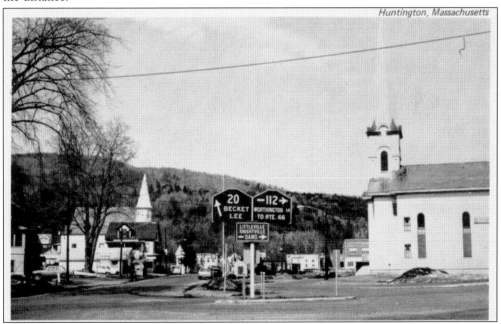

Huntington, Massachusetts

JUNCTION OF WORTHINGTON AND RUSSELL ROADS, HUNTINGTON. Considerable development had taken place in Huntington during the decades between this and the previous photograph. Streets were paved and a traffic circle had been installed where several streets converged. Signs and arrows directed drivers to their various destinations, including those traveling on Route 20 to Becket and Lee, farther to the west.

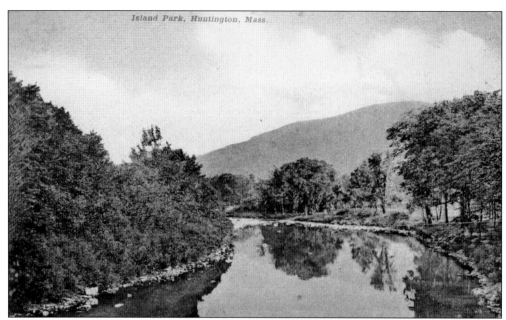

ISLAND PARK, HUNTINGTON. The Westfield River flowed serenely through Huntington, providing scenic beauty to the community as well as opportunities for swimming, fishing, and boating. This park near the center of the community was a popular location for picnics or simply a quiet stroll along the riverbank.

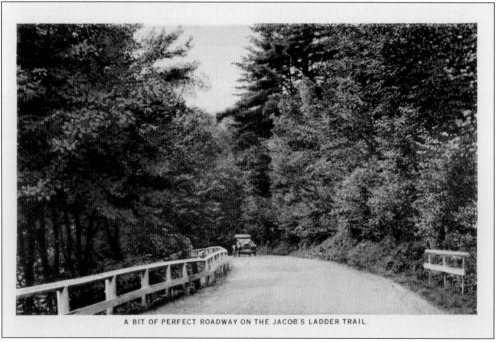

PERFECT ROADWAY ON JACOB'S LADDER TRAIL. The descriptive line at the bottom of this card is indicative of the pride of the builders of Jacob's Ladder Trail. Although the road surface was gravel, it was state-of-the-art for the time and a vast improvement over most earlier roads. A motorist in an early 1930s model automobile was taking full advantage of this excellent road.

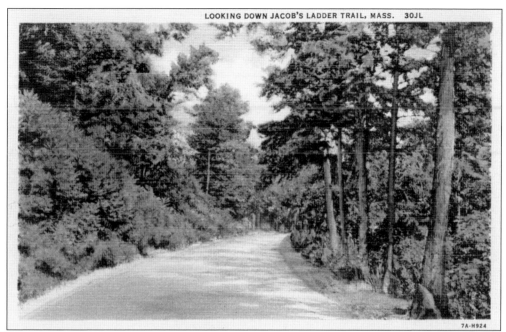

7A-H924

LOOKING DOWN JACOB'S LADDER TRAIL. Jacob's Ladder Trail was noted for its different color combinations in the ever-changing landscape. This photograph shows the highway heading into a heavily wooded section of the highway. It clearly shows that road building techniques of the day did not include curbs and ditches to improve drainage following rains and winter snows.

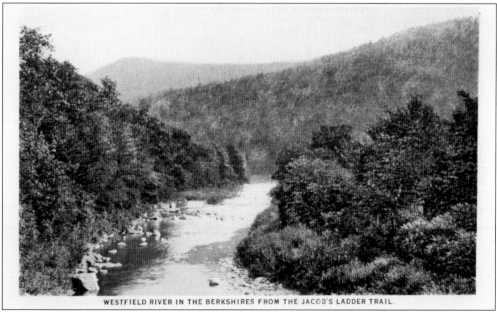

WESTFIELD RIVER IN THE BERKSHIRES FROM THE JACOB'S LADDER TRAIL.

WESTFIELD RIVER FROM JACOB'S LADDER TRAIL. Another face of the Westfield River is shown on this card farther along Jacob's Ladder Trail. Here, the road overlooks a section that is shallow, rocky, and rapid. The term "wild and scenic" had not yet been coined during Jacob's Ladder Trail's early years, but there was no doubt that the Westfield River would qualify when Congress enacted the Wild and Scenic Rivers System in 1968.

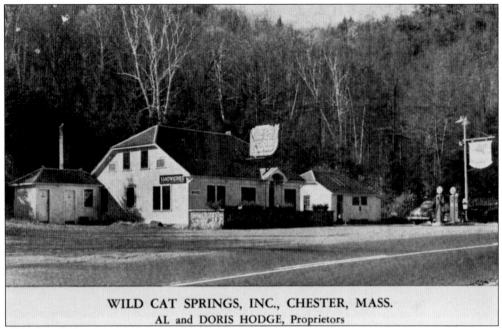

WILD CAT SPRINGS, INC., CHESTER, MASS.
AL and DORIS HODGE, Proprietors

WILD CAT SPRINGS, CHESTER. This roadhouse was a fixture on Route 20 for more than 50 years. Note the outdoor restrooms at the left of the photograph. Wild Cat Springs initiated the annual Westfield River Canoe Race, which is said to be the oldest continuous canoe race in the country. The finish line was in Russell, about 10 miles downstream. The original prize was two cases of beer.

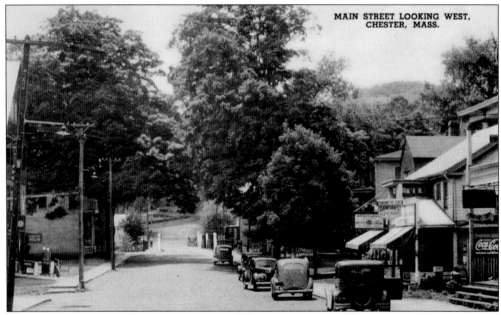

MAIN STREET LOOKING WEST, CHESTER, MASS.

MAIN STREET LOOKING WEST, CHESTER. Chester was one of many small villages in the Berkshires through which early travelers passed on Jacob's Ladder Trail. Drivers who ventured down Chester's idyllic Main Street in the 1930s, when this photograph was taken, might have stopped for a coke, a beer at Dawson's Bar, or a meal in the restaurant.

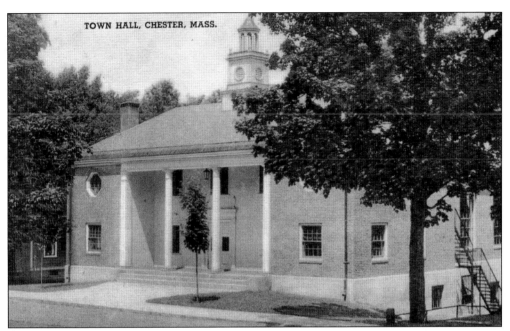

TOWN HALL, CHESTER, MASS.

TOWN HALL, 15 MIDDLEFIELD ROAD, CHESTER. This civic building, complete with a columned portico and cupola, is located just north of the junction of Route 20 and Middlefield Road, where it has served as the longtime seat of local government. In more recent years, the auditorium of Chester Town Hall has been the venue for theater productions.

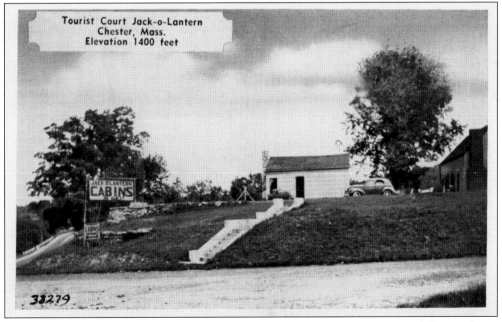

Tourist Court Jack-o-Lantern
Chester, Mass.
Elevation 1400 feet

JACK O LANTERN CABINS

38279

JACK-O-LANTERN TOURIST COURT, CHESTER. No information is provided to indicate why this unusual name was chosen for this 11-unit tourist court located on Route 20 near Chester. Amenities appreciated by early travelers—running water, inside toilets and showers, and cooking facilities—all were available. Doubtless the nearby trout fishing and deer hunting mentioned on the back of the card would have appealed to outdoorsmen.

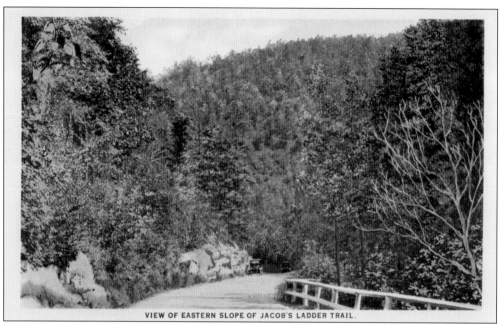

VIEW OF EASTERN SLOPE OF JACOB'S LADDER TRAIL.

VIEW OF THE EASTERN SLOPE OF JACOB'S LADDER TRAIL. The caption on the back of this card describes Jacob's Ladder Trail as "a superb motorway of scenic splendor, connecting the Housatonic River and Westfield River Valleys. On the direct highway east and west across Massachusetts, it rises at a gradient of six percent, by graceful curves, to the summit of 2300 ft. above tidewater."

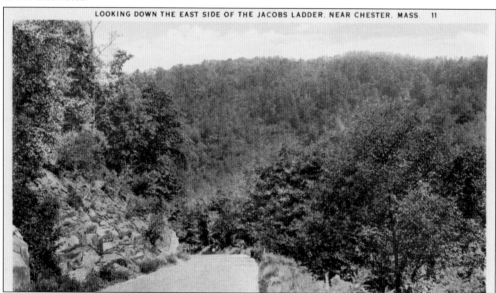

LOOKING DOWN THE EAST SIDE OF THE JACOBS LADDER, NEAR CHESTER, MASS. 11

JACOB'S LADDER ROADWAY NEAR CHESTER. Jacob's Ladder Trail continued its gradual ascent as it progressed toward the mountain's summit. Today, the Berkshires are not considered a serious obstacle for automobiles, but in the 1920s and 1930s they presented a significant challenge. The climb often resulted in overheated radiators that required stops to add water. Motorists who experienced this misfortune could enjoy the beautiful scenery while they waited for their motors to cool off.

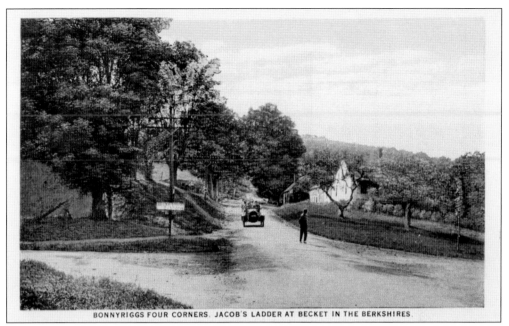

BONNYRIGGS FOUR CORNERS. JACOB'S LADDER AT BECKET IN THE BERKSHIRES.

BONNY RIGG FOUR CORNERS. Bonny Rigg appeared on Massachusetts maps of the early 1930s as a specific community, but it quickly disappeared as later versions were published. In this view, it appears to be simply a country crossroads. The directional sign points to Becket and East Otis. The intersection now is the junction of Route 20 and Massachusetts Route 8.

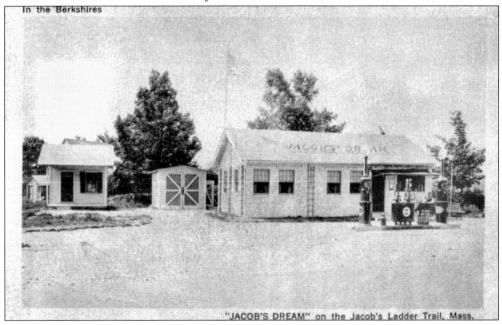

In the Berkshires

"JACOB'S DREAM" on the Jacob's Ladder Trail, Mass.

JACOB'S DREAM, JACOB'S LADDER TRAIL. This cabin camp and filling station were located a short distance east of the Jacob's Ladder Trail summit. No doubt travelers who passed by during the 1930s found it a convenient stop for gas and refreshments, or possibly spend the night in one of the tiny cabins. A gentleman, probably the proprietor, was relaxing in front of the station when this photograph was taken.

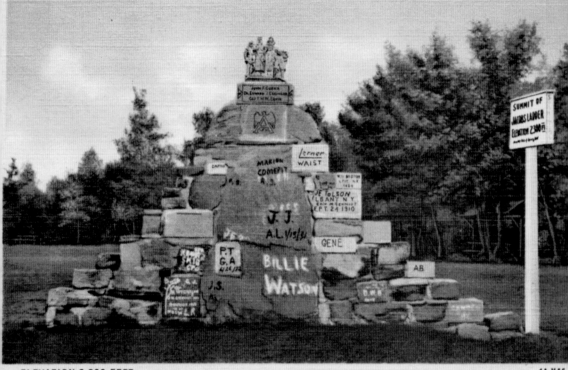

ELEVATION 2,300 FEET 4A-H46

THE ROCK PILE AT THE SUMMIT OF JACOB'S LADDER TRAIL. The rock pile, officially called a cairn, came into being on the day Jacob's Ladder Trail was opened. On September 10, 1910, a picnic was held at the summit attended by an estimated 2,000 automobile enthusiasts, dignitaries, and citizens from the surrounding farms and villages. The celebration marked the completion of the first motor route over a mountain range and was a giant step forward in motorized transportation. No longer would mountains be insurmountable obstacles to automobiles and trucks. Mrs. George Westinghouse, wife of the American industrialist, raised the flag at the dedication. Many visitors brought stones to be placed in a pile at the site of the celebration. Since then, other persons have contributed to the pile as they crossed the summit. This c. 1920s photograph shows that graffiti is not just a modern phenomenon.

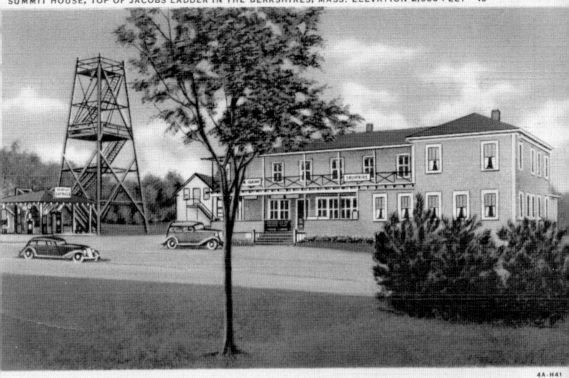

4A-H41

SUMMIT HOUSE AND TOWER, JACOB'S LADDER TRAIL. The Summit House, established in 1916, was a destination in itself along Jacob's Ladder Trail. At 2,300 feet, it was the highest point on Jacob's Ladder Trail, and few travelers passed by without making a stop. The Summit House offered gifts and souvenirs plus a bar, soda fountain, and restaurant. Patrons could enjoy their meal in the dining room or at one of the picnic tables on the grounds while taking in the fresh air at one of Massachusetts's highest elevations. Automobiles were serviced at the adjoining station, where Secony gas and oil products were featured. Several small cabins were available on the property. A favorite attraction for visitors was the observation tower with its swiveling telescope mounted on the top level. The charge for viewing from the tower was 10¢. Children enjoyed the adjoining deer farm, where they had close-up views of the animals.

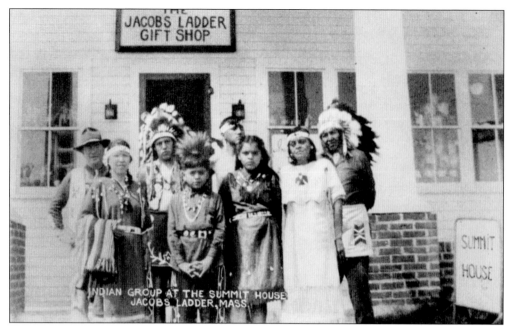

INDIAN GROUP AT THE SUMMIT HOUSE, JACOB'S LADDER TRAIL. There is nothing on this card to indicate the reason why this group of Native Americans was posing on the porch of the Summit House. Possibly they were descendants of the original inhabitants of the region, or maybe they were employed by the inn to lend authenticity to the heritage of the roadway.

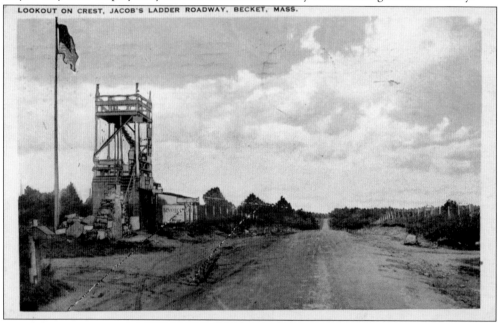

LOOKOUT ON THE CREST, JACOB'S LADDER ROADWAY. Most visitors to the Summit House took time to climb to the top of the 50-foot-high observation tower to experience the magnificent Berkshire mountain panoramas in every direction. The tower was illuminated at night with lights strung around the first and top decks, and the observation platform was equipped with a swiveling telescope for visitors' use.

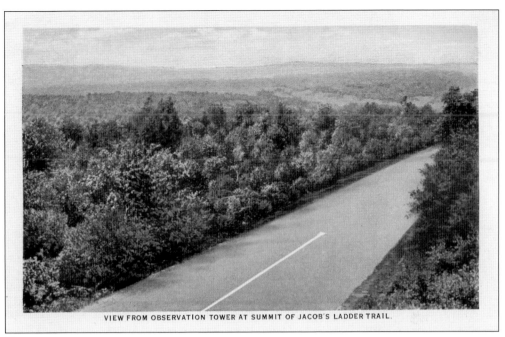

VIEW FROM OBSERVATION TOWER AT SUMMIT OF JACOB'S LADDER TRAIL.

VIEW FROM THE OBSERVATION TOWER, JACOB'S LADDER TRAIL. The top deck of the observation tower was well above treetop height, which provided unobstructed views of the magnificent roadway and scenic beauty of the surrounding area. On clear days, the view was said to include four states: Massachusetts, New York, Vermont, and Connecticut.

BANDIT'S CURVE, JACOB'S LADDER ROADWAY, BECKET. In the early automobile era, many roads, including Jacob's Ladder, were identified by names rather than numbers. Local residents frequently applied colorful names to specific sites along the way. One such place was Bandits' Curve near Becket. No reason could be found as to why this name was selected.

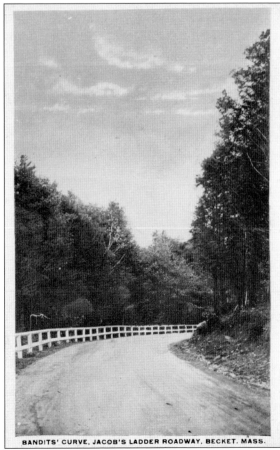

BANDITS' CURVE, JACOB'S LADDER ROADWAY, BECKET, MASS.

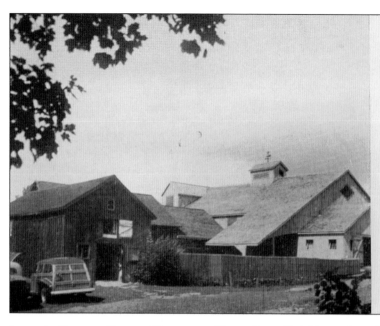

JACOB'S PILLOW DANCE THEATRE

Near Lee, Mass.

•

Ted Shawn
Managing Director

Joseph Franz
Architect

•

Formally opened
JULY 9
1942

JACOB'S PILLOW DANCE THEATER, NEAR LEE. Ted Shawn bought the farm that was to become his legacy in 1931. In 1942, he opened the country's first theater devoted exclusively to dance. For over seven decades, it has ranked among the world's best centers for the promotion of dance. Almost every international dance artist has appeared at Jacob's Pillow. In addition to its famous Dance Festival, Jacob's Pillow also operates a school where aspiring dancers receive instruction from world renowned teachers. Both Shawn and design engineer Joseph Franz wanted the rustic facility to harmonize with the original farm buildings. Their goal was accomplished as evident by comparing the theater building (top photograph) with the farmhouse and outbuildings shown in the bottom photograph. Jacob's Pillow is a National Historic Landmark.

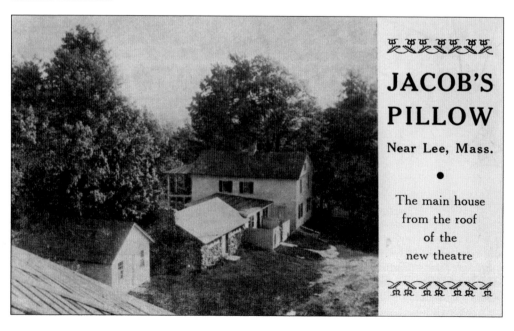

JACOB'S PILLOW

Near Lee, Mass.

•

The main house
from the roof
of the
new theatre

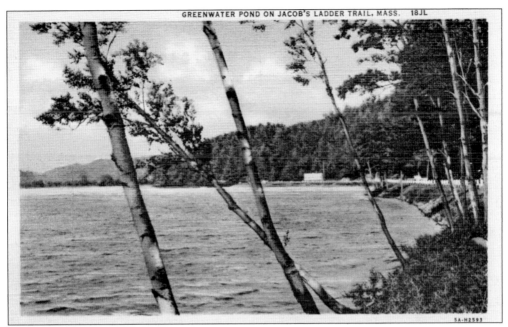

GREENWATER POND ON JACOB'S LADDER TRAIL. Greenwater Pond, one of the most scenic locations on the Jacob's Ladder Roadway, has been enjoyed by motorists long before the road was incorporated into the federal highway system. The word "pond" may be misleading, as it is actually a small lake that reaches a depth of 60 feet in some places. It has long been a popular spot for fishing (in both summer and winter) and is noted for perch, bullheads, and several species of trout. The establishment of Route 20 in 1926 brought even more attention to the highway, and improvements to the roadbed made it more convenient for travelers to visit the Greenwater Pond area. The two cards on this page show examples of why this area was so popular. The natural beauty is evident in both photographs as is the proximity of the highway to the lake (below).

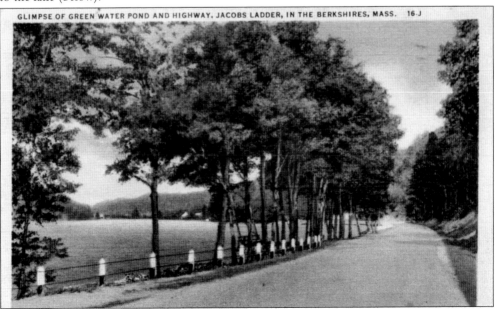

GLIMPSE OF GREEN WATER POND AND HIGHWAY, JACOBS LADDER, IN THE BERKSHIRES, MASS. 16-J

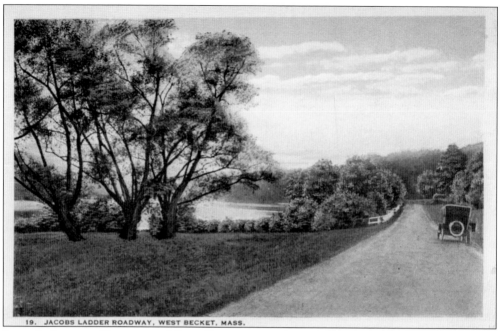

19. JACOBS LADDER ROADWAY, WEST BECKET, MASS.

JACOB'S LADDER ROADWAY, WEST BECKET. Westbound travelers on Jacob's Ladder Trail would almost have completed their scenic drive when they arrived at this idyllic location near West Becket. For those going east, the treat was still ahead. The car in the photograph appears to have parked at the side of the road, possibly so its occupants could enjoy the view.

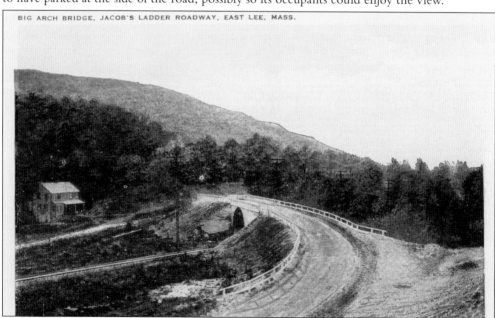

BIG ARCH BRIDGE, JACOB'S LADDER ROADWAY, EAST LEE, MASS.

BIG ARCH BRIDGE, JACOB'S LADDER ROADWAY, EAST LEE. This bridge's design, plus the sweeping curve leading to it, may have been reasons for the name Big Arch. The postcard was mailed in 1928, so improvements to the road leading to the bridge probably were a benefit of Jacob's Ladder Trail being incorporated into Route 20. Originally, this bridge crossed over the trolley line connecting Huntington and Lee.

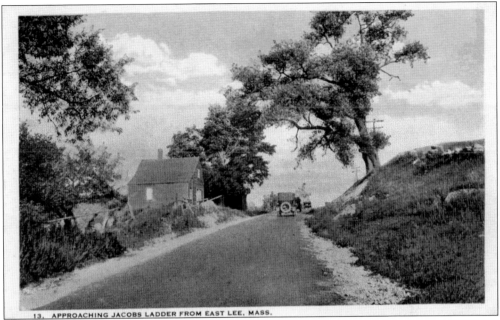

13. APPROACHING JACOBS LADDER FROM EAST LEE, MASS.

JACOB'S LADDER ROADWAY, EAST LEE. From its inception, Jacob's Ladder has been a scenic byway, but it also was a farm-to-market road that connected local residents to various communities along its path. No doubt farmers in this area of western Massachusetts enjoyed the practical advantages of the road as well as its scenery.

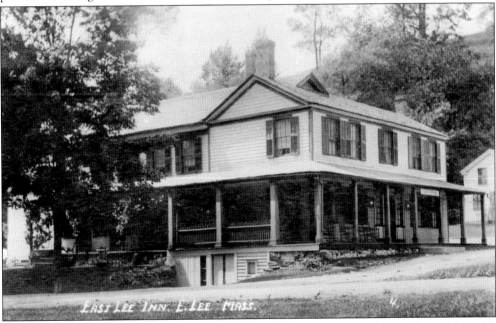

EAST LEE INN. E. LEE. MASS.

EAST LEE INN, EAST LEE. There is no information on this postcard to indicate when this photograph was taken, but a penciled note on the back describes the location of the East Lee Inn as "Sitting on Highway 20." This would indicate its being in operation after 1926, the year Route 20 was designated a federal highway, although the photograph might have been taken even earlier.

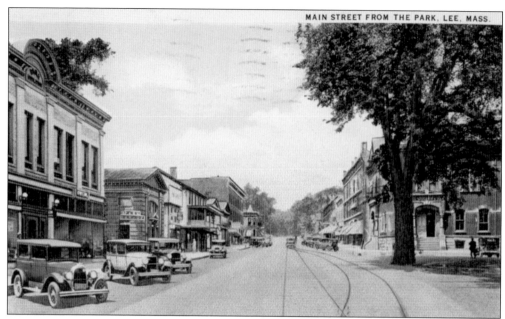

MAIN STREET, LEE. Before automobiles became the accepted mode of travel, trolleys provided public transportation in most cities. This postcard illustrates the coexistence of trolleys and automobiles on Lee's Main Street in the late 1920s. The configuration of the tracks indicates that the city park was a primary stop. Shade from the large tree must have provided welcome relief from the heat for riders waiting to board the trolleys.

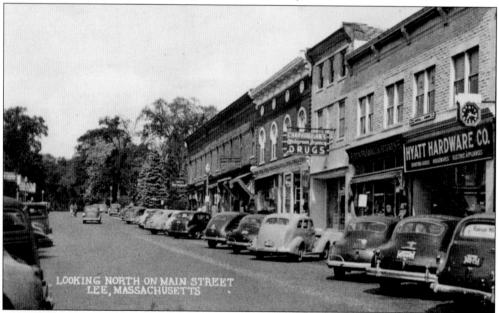

LOOKING NORTH ON MAIN STREET
LEE, MASSACHUSETTS

MAIN STREET, LEE. This postcard shows Lee's Main Street approximately 10 years after the previous postcard. The trolley tracks had been removed and the street repaved. Note also the changed parking pattern on the two cards. The cars are parked diagonally, which was characteristic of the time, but in the earlier photograph they are backed into the spaces rather than heading into them as in the later photograph.

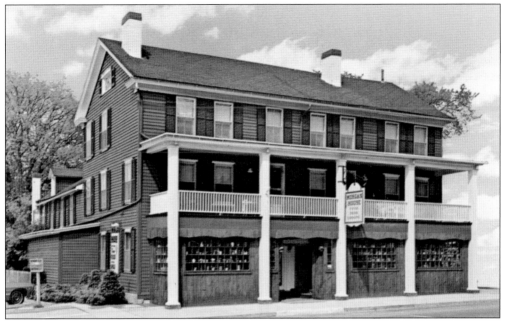

THE MORGAN HOUSE, 33 MAIN STREET, LEE. Originally a private residence, Edwin Morgan acquired this stately building in 1855, when he christened the establishment Morgan House Inn and opened its doors to visitors. The tradition of providing a comfortable rest stop has continued for more than 150 years. Many illustrious figures have enjoyed Morgan House hospitality, including Gen. U.S. Grant, George Bernard Shaw, and Pres. Grover Cleveland.

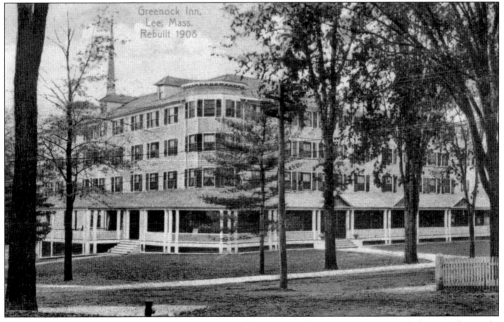

GREENOCK INN, LEE. This postcard shows the Greenock Inn as it appeared during the early 20th century when the inn was at its peak in popularity. Located just off Main Street in Lee, the hotel was host to travelers on Route 20 and served as a gathering place for local residents and wealthy patrons who enjoyed spending their summers in the Berkshires.

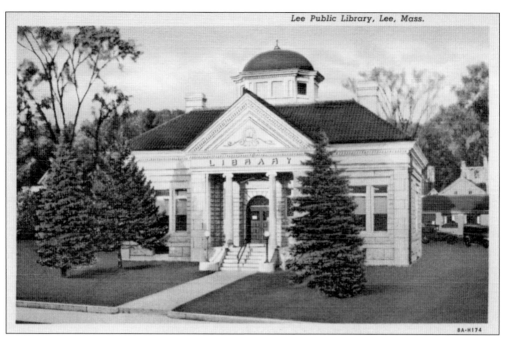

Lee Public Library, Lee, Mass.

PUBLIC LIBRARY, 100 MAIN STREET, LEE. This is the only remaining Carnegie Library in the Berkshires. Construction began in 1908, and it opened in 1911. The marble in the building was quarried locally. Lee marble is recognized for its high quality, and these quarries also furnished the marble for the extension of the Capitol in Washington, DC, and for St. Patrick's Cathedral in New York City.

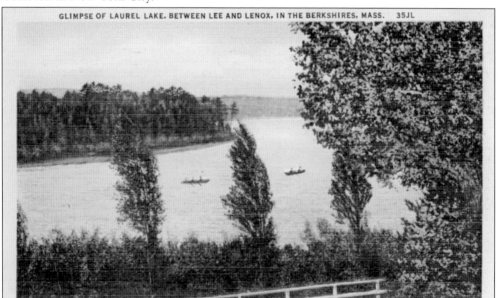

GLIMPSE OF LAUREL LAKE, BETWEEN LEE AND LENOX, IN THE BERKSHIRES, MASS. 35JL

LAUREL LAKE, LEE. Laurel Lake, located just north of Lee, has been another popular recreational site along Jacob's Ladder Trail. The lake is small—consisting of only a 170-acre surface area—but like Greenwater Pond several miles to the east, it has provided exceptional scenery and abundant opportunities for swimming, fishing, and boating during the warm months and ice fishing, skating, and cross-country skiing in the winter.

Six

THE LEBANON VALLEY

The most westerly section of Historic Route 20 in Massachusetts extends from a few miles east of Lenox to the New York border. The distance is short—only 15 miles—but the history, culture, and scenery more than compensate for its brevity. The historic towns of Lenox and Pittsfield are located directly on the highway, and in addition to being commercial centers, both have quaint main streets, significant architecture, and historic sites dating to the early years of the Commonwealth. At the turn of the 20th century, the Berkshire Mountains were a favorite summer retreat for wealthy industrialists. Summer cottages flourished near Lenox, rivaling those in Newport, Rhode Island. Following the decline of the area's Gilded Age, many of the mansions were converted into inns and resorts and continued to be destinations for travelers on Route 20. Another attraction was Tanglewood, the summer home of the Boston Symphony Orchestra, located only minutes from Lenox. Since 1936 (with the exception of the World War II years), concerts and operas have been performed annually during the summer season.

Descending the mountain west of Pittsfield, early travelers on historic Route 20 were struck by the beauty of the scene below extending from Massachusetts into New York. The broad valley's farms and small villages presented a picture of serenity and comfort that had characterized the region for decades. The predominant site was Shaker Village, commonly identified with Hancock, Massachusetts, close to the New York border. The Shaker religious sect flourished in the area during the 19th and early 20th centuries and populated several villages throughout the valley. It was founded by charismatic English-born Ann Lee (1736–1784), who immigrated to America in 1774 and gathered sufficient followers to establish a dynamic religious community. They were among the largest and most successful of the utopian communal societies of the day. Modernization of agricultural methods and the naturally declining population of the celibate community marked the demise of the Shakers. The sect dissolved in 1947, but Shaker Village remained and is now an open-air museum that has been designated a National Historic Landmark.

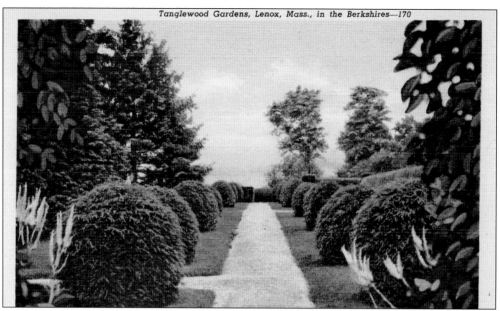

TANGLEWOOD GARDENS, LENOX. In 1850, Nathaniel Hawthorne rented a cabin on the Berkshire estate of William Aspinwall Tappan, where he wrote his classic book *Tanglewood Tales*. "Tanglewood" appealed to the Tappan family and was adopted for the estate. In 1936, the Boston Symphony Orchestra was invited to present concerts at Tanglewood, and in 1937, Mary Aspinwall Tappan donated the estate to the orchestra for use as its summer home. With only one hiatus during World War II, the Boston Symphony Orchestra has performed at Tanglewood every year since. Tanglewood is known worldwide for its high-quality music and also for its educational programs for talented young musicians. Not to be overlooked are the Tanglewood gardens, shown in the top and bottom photographs. For almost 75 years, the beautiful grounds have enhanced the enjoyment of the Tanglewood experience.

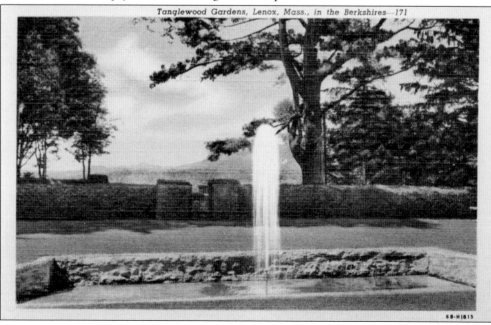

MUSIC SHED AND OPERA-CONCERT HALL AT TANGLEWOOD, LENOX.

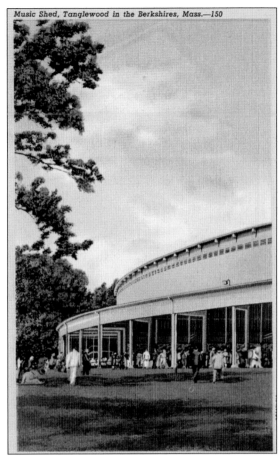

Music Shed, Tanglewood in the Berkshires, Mass.—150

The first Boston Symphony Orchestra concert at Tanglewood in 1936 was presented under a tent with many of the audience seated on folding chairs or on the ground. After the estate was donated to the orchestra, a successful fundraising drive resulted in a 5,000–seat structure called the Music Shed (top photograph). The original design by Finnish architect Eliel Saarinen proved to be too expensive, and it was modified by design engineer Joseph Franz, who also designed the Jacob's Pillow Dance Theater. Completed in 1938, the fan-shaped roof covers the stage and many of the seats, but the lawn remains the favored place of many patrons. The Opera-Concert Hall (bottom photograph) is the second major performance venue on the grounds. It provides dressing rooms and stages equipped to present operas.

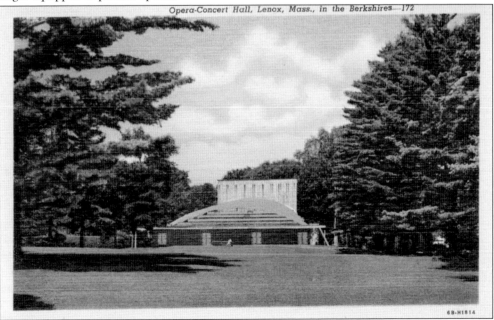

Opera-Concert Hall, Lenox, Mass., in the Berkshires—172

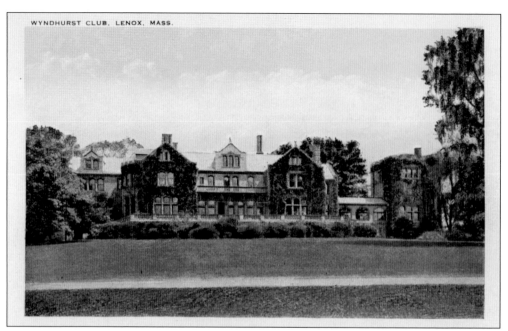

WYNDHURST, 55 LEE ROAD, LENOX. Wyndhurst, built by John Sloane in 1894, was among the finest of many Berkshire "cottages." The Reverend Henry Ward Beecher once owned the original Wyndhurst farm. His sister Harriet Beecher Stowe, author of *Uncle Tom's Cabin*, lived on the property in a small farmhouse. Wyndhurst eventually was deeded to the Society of Jesus for use as a school for boys.

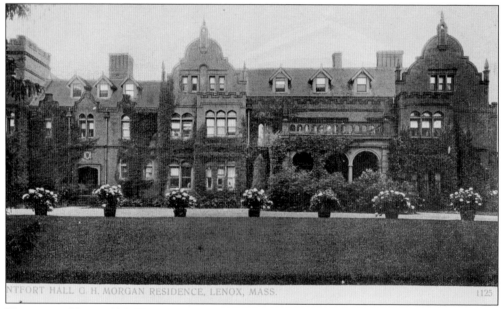

NTFORT HALL G. H. MORGAN RESIDENCE, LENOX, MASS.

VENTFORT HALL, 104 WALKER STREET, LENOX. This imposing mansion was built in 1893 for Sarah Morgan, sister of J.P. Morgan, and throughout the area's Gilded Age was a center of activity for the rich and famous summer residents. Constructed of red brick with brownstone trim, the 50-room house had 15 bedrooms, 13 bathrooms, and 17 fireplaces. Ventfort Hall is listed in the National Register of Historic Places.

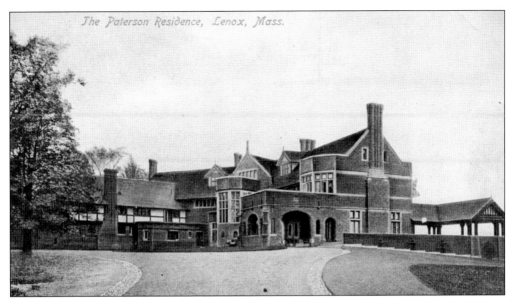

The Paterson Residence, Lenox, Mass.

BLANTYRE, 16 BLANTYRE ROAD, LENOX. Blantyre was another grand summer home in Lenox in the early 1900s. It was built by Robert Paterson, a successful merchant, on the majestic scale of his family's ancestral home in Scotland. After the Great Depression, the house fell into disrepair but fortunately was purchased in 1980 and transformed into a luxury resort.

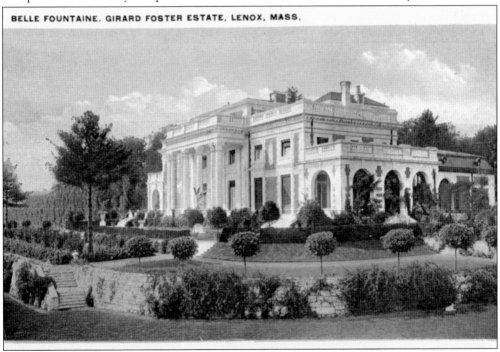

BELLE FOUNTAINE. GIRARD FOSTER ESTATE, LENOX, MASS.

BELLE FOUNTAINE, LENOX. Belle Fountaine was said to be the most elegant of the Lenox summer homes. It was built by Giraud Foster, a wealthy financier, in the style of an 18th-century French palace. Foster was the longest living, and ultimately the last, of the social elite who summered in Lenox. He died in 1945 at the age of 95, thus bringing Lenox's Gilded Age to a close.

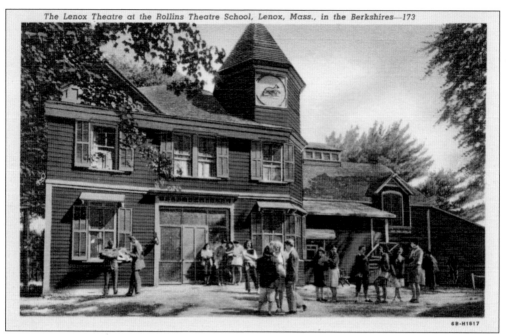

LENOX THEATER AT THE ROLLINS THEATER SCHOOL, LENOX. Leighton Rollins Jr., who came to Lenox after a successful theater career throughout New England and New York, founded this community playhouse and school in 1944. He was especially interested in helping young actors through summer stock productions. A peripatetic individual, Rollins remained in Lenox for only five years before moving on to Arizona and California.

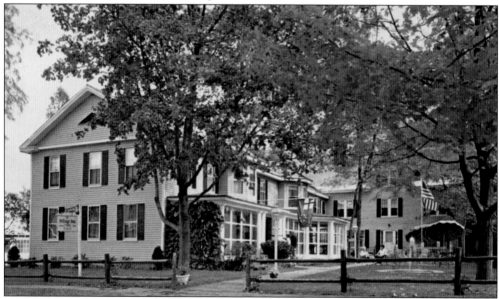

VILLAGE INN, JUNCTION OF MAIN AND WALKER STREETS, LENOX. The Village Inn was built in 1771, placing it among the oldest inns in the Berkshires. It originally consisted of a large Federal-style house and two outbuildings. Later, the buildings were joined together, resulting in the building seen today. This charming inn has welcomed the local population and travelers through the community for more than 200 years.

112

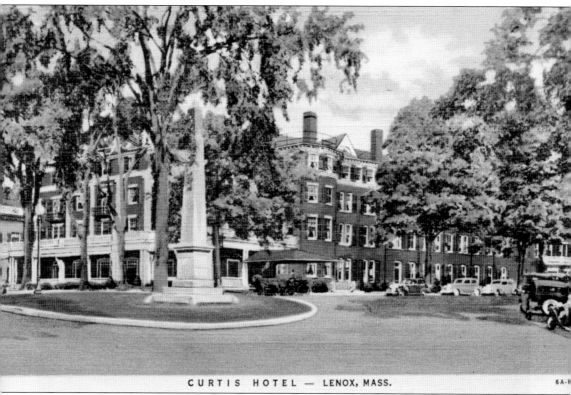

CURTIS HOTEL — LENOX, MASS. 6A-H

CURTIS HOTEL, 5 WALKER STREET, LENOX. The luxurious Curtis Hotel served as Lenox's social headquarters for decades, hosting wealthy residents from the "cottages" as well as early automobile enthusiasts. A 1914 advertisement describes the hotel as follows: "This well known hostelry, established in 1829, and recently rebuilt is located in the center of the Berkshire Hills, at an elevation of 1300 feet. It has come to be known as a famous stopping place for automobile tourists, particularly those following the Ideal Tour through New England." The Ideal Tour was an approximately 900-mile route through New England, so named by the Automobile Club of America. Its purpose was to afford owners of motor cars the greatest possible enjoyment that can be obtained from an automobile. The idea was to describe a round trip through New England that would lead through scenic areas both on the outward and homeward journey and furnish pleasant stopping places with a good hotel at the end of each day's run.

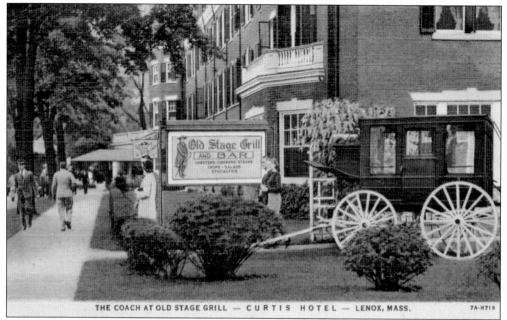

THE COACH AT OLD STAGE GRILL — C U R T I S H O T E L — LENOX, MASS. 7A-H719

OLD STAGE GRILL, CURTIS HOTEL, 5 WALKER STREET, LENOX. One of the main attractions of the Curtis Hotel was its famous restaurant and bar, the Old Stage Grill, complete with an authentic stagecoach that occupied a prominent position on the green beside the hotel.

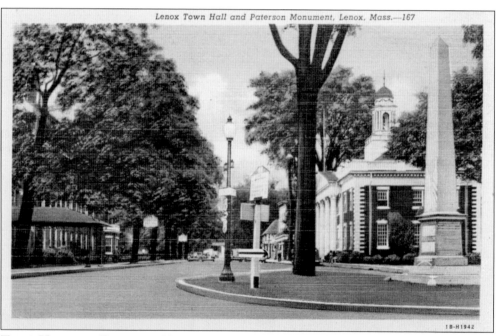

Lenox Town Hall and Paterson Monument, Lenox, Mass.—167

TOWN HALL AND PATERSON MONUMENT, LENOX. The junction of Main, Walker, and West Streets has long been the hub of activity in Lenox. Route 20 went through the square, passing several important structures including the Paterson Monument and Lenox Town Hall. The monument was dedicated to the memory of Gen. John Paterson, a Lenox citizen who became a Revolutionary War hero fighting beside George Washington in several decisive battles.

114

CHURCH ON THE HILL, LENOX.
This church, built in 1805, replaced a meetinghouse that had been built in 1769. An excerpt from a speech at the church's centennial in June 1906 provides insight into the necessity for the original church to be replaced: "The congregation desired to worship in a house less liable to collapse over their heads or go to ruin between Sabbaths." The church is in the National Register of Historic Places.

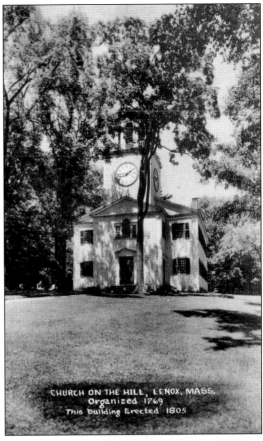

CHURCH ON THE HILL, LENOX, MASS.
Organized 1769
This Building Erected 1805

THE ASPINWALL, LENOX. The Aspinwall Hotel, one of the most fashionable hostelries in the Berkshires, stood along Route 20 just outside of Lenox. Built in 1902, the hotel boasted the latest amenities, and for 30 years it played host to wealthy industrialists and financiers. Tragically, the 400-room wooden structure burned to the ground in April 1931. The fire was attributed to drunken youths who left behind a lit cigarette.

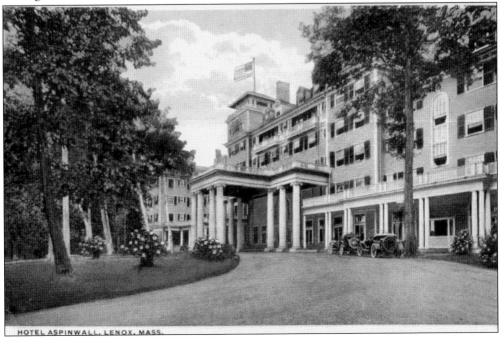

HOTEL ASPINWALL, LENOX, MASS.

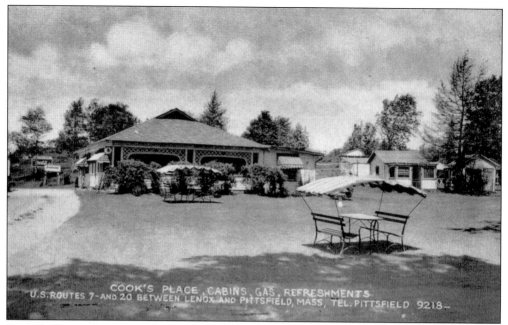

COOK'S PLACE CABINS, PITTSFIELD. Guests could enjoy a picnic at one of the shaded tables on the large lawn at this tourist camp located on Routes 7 and 20 between Lenox and Pittsfield. A service station providing gas and refreshments also was available on the premises.

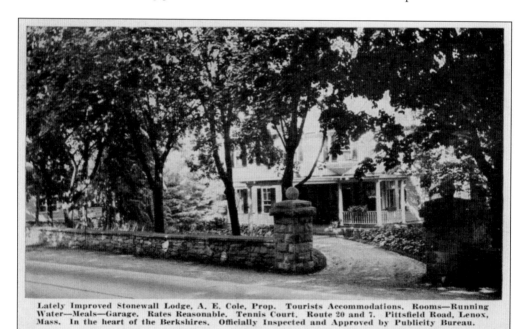

Lately Improved Stonewall Lodge, A. E. Cole, Prop. Tourists Accommodations, Rooms—Running Water—Meals—Garage. Rates Reasonable. Tennis Court. Route 20 and 7. Pittsfield Road, Lenox, Mass. In the heart of the Berkshires. Officially Inspected and Approved by Publicity Bureau.

STONEWALL LODGE, ROUTE 20 AND 7, PITTSFIELD. The name of this tourist accommodation was derived from the attractive stone wall and gates that separated the property from the street. In addition to comfortable rooms with running water and garages, guests had use of the tennis courts behind the house. The Stonewall Lodge was inspected and approved by the Publicity Bureau, an early travelers' advisory service.

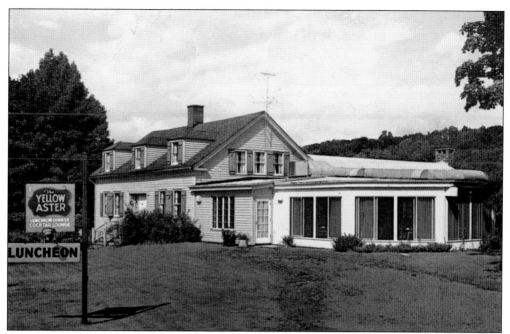

YELLOW ASTER RESTAURANT, ROUTES 7 AND 20, PITTSFIELD. An addition had been made to this Colonial-style house converting it into a comfortable neighborhood restaurant. Located two and a half miles south of the heart of downtown Pittsfield, it featured gourmet dining in a delightful country atmosphere.

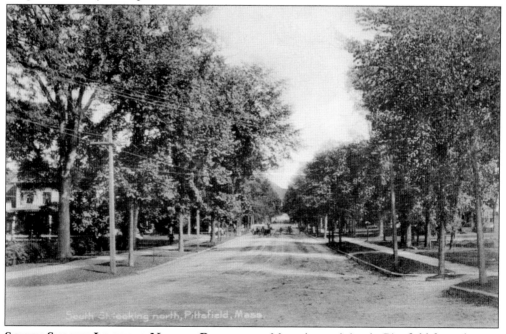

SOUTH STREET LOOKING NORTH, PITTSFIELD. Motorists arriving in Pittsfield from the east would have had this view of one of Pittsfield's pleasant residential neighborhoods. Characteristic of many smaller Route 20 communities, the streets entering and leaving the community were lined by mature trees, well-kept lawns, and stately homes with large front porches.

BROOKHAVEN TOURIST ACCOMMODATIONS, 378 SOUTH STREET, PITTSFIELD. Located on Routes 20 and 7 in the "Heart of the Berkshires," this facility offered shady, spacious grounds for relaxation near churches, movies, and very desirable restaurants. It was also near lakes and ski areas. The station wagon in the driveway dates this card to the early 1940s.

MOHAWK INN, 170 SOUTH STREET, PITTSFIELD. This is another example of a stately home on Route 20 that had been converted into an inn. The large, comfortable front porch and its location within easy walking distance of downtown Pittsfield probably added to its appeal.

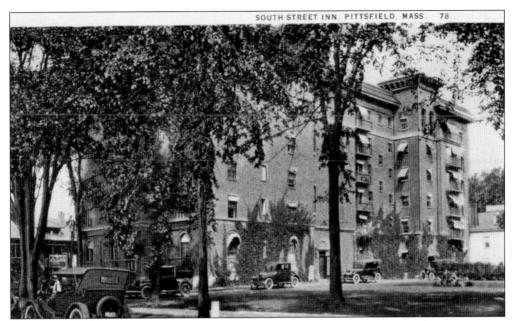

SOUTH STREET INN, PITTSFIELD. The name of this establishment conveys the impression of a smaller, more intimate accommodation, but it was actually a five-story hotel located near the junction of South and Housatonic Streets near the center of Pittsfield. The hotel's central location made its dining room a popular place to meet friends and business associates.

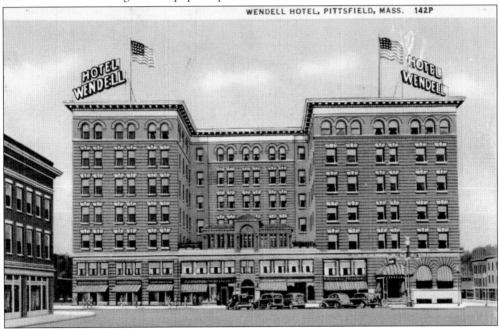

THE WENDELL HOTEL, PITTSFIELD. The six-story Wendell Hotel occupied a prominent position on Park Square in the heart of Pittsfield's business district and for the first half of the 20th century was a center of business and social life in western Massachusetts. As indicated by the automobiles parked at the curb, this photograph shows the hotel as it appeared in the early 1930s.

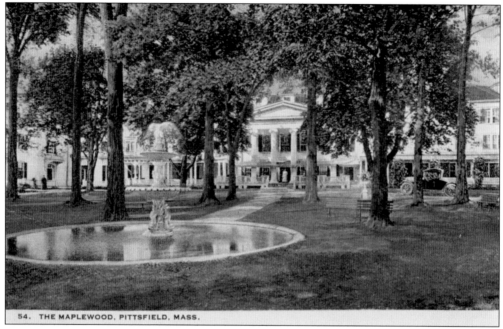

54. THE MAPLEWOOD, PITTSFIELD, MASS.

THE MAPLEWOOD, PITTSFIELD. From 1887 until the 1930s, the Maplewood was among the finest resorts in the Berkshires, offering comfortable guest suites, a billiard room, bowling alley, tennis and croquet courts, and a symphony pipe organ. Unfortunately, the resort fell on hard times and closed in 1940. The hotel's distinguishing columns were donated to Tufts University, and its beautiful metal fountains were melted down for the war effort.

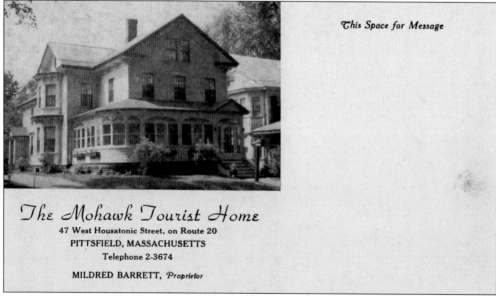

This Space for Message

The Mohawk Tourist Home
47 West Housatonic Street, on Route 20
PITTSFIELD, MASSACHUSETTS
Telephone 2-3674

MILDRED BARRETT, Proprietor

MOHAWK TOURIST HOME, 47 HOUSATONIC STREET, PITTSFIELD. The style of this card indicates that it is older than the card on a previous page showing a Mohawk Inn elsewhere in Pittsfield. If both Mohawk tourist accommodations were in business at the same time, the similarity of their names may have been confusing to potential customers. This Mohawk Inn was located on Route 20 west of the downtown business district.

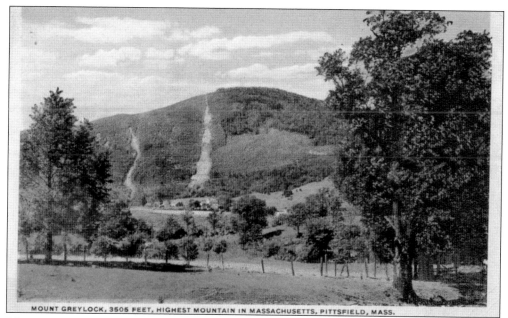

MOUNT GREYLOCK, 3505 FEET, HIGHEST MOUNTAIN IN MASSACHUSETTS, PITTSFIELD, MASS.

MOUNT GREYLOCK, VIEW FROM PITTSFIELD. At 3,505 feet, Mount Greylock, north of Pittsfield, is Massachusetts's highest point. The mountain is part of the Taconic range and is clearly visible to travelers on Route 20. For years, Mount Greylock has been a favorite site for hiking. As a component of the 2,179-mile Appalachian Trail, it provides challenges for day-hikers and long distance enthusiasts alike.

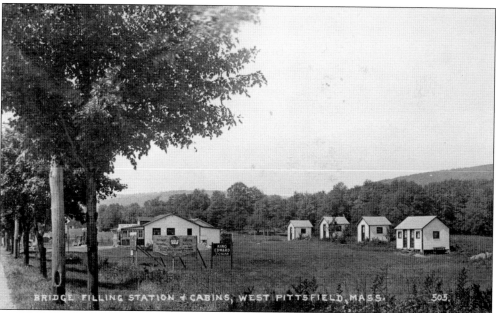

BRIDGE FILLING STATION + CABINS, WEST PITTSFIELD, MASS. 505.

BRIDGE FILLING STATION AND CABINS, WEST PITTSFIELD. Three single cabins and one double cabin were available for travelers at the Bridge tourist camp. Those wishing to service their cars could do so at the filling station. The larger sign in the foreground tells customers that Gulf Oil products were featured, including "No Nox" gasoline and Supreme motor oil. The smaller sign advertised King Edward Cigars.

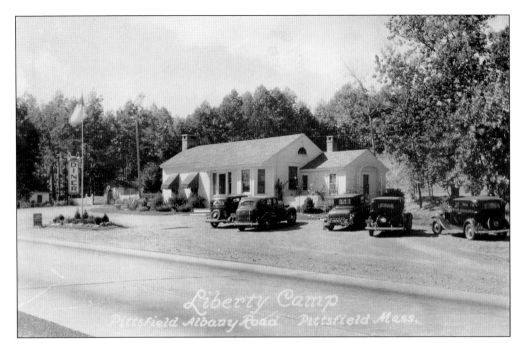

LIBERTY CAMP, PITTSFIELD–ALBANY ROAD, PITTSFIELD. Liberty Camp was literally carved out of the dense woods that bordered Route 20 west of Pittsfield. It offered meals and beverages in the main building, and overnight guests could stay in one of the small cabins accessible by gravel paths. When these photographs were taken, it appears that business was booming at the diner and tavern shown in the upper photograph, as several 1930s-era automobiles were in the parking lot. The cabins in the bottom photograph were attractively placed near the woods and away from the road, assuring quiet and privacy, but none appeared to be occupied.

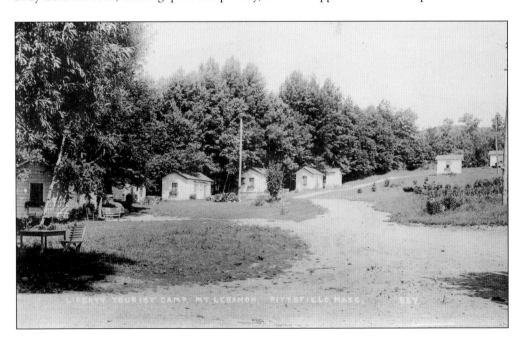

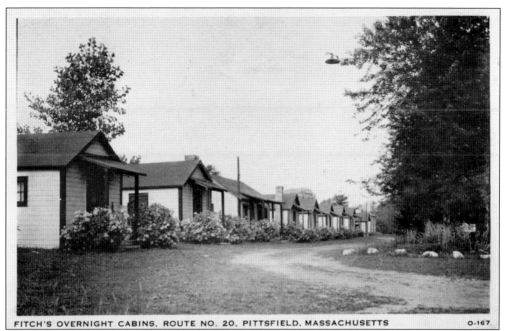

FITCH'S OVERNIGHT CABINS, ROUTE NO. 20, PITTSFIELD, MASSACHUSETTS O-167

FITCH'S OVERNIGHT CABINS, ROUTE NO. 20, PITTSFIELD. As indicated by the chimney on each of the cabins in this 1930s tourist camp, central heating had not yet arrived. Guests warmed their units with either wood or fuel oil stoves. The proprietors had done their best to make the site attractive with carefully placed rocks and abundant bushes.

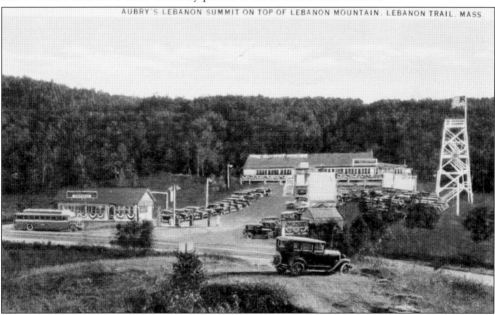

AUBRY'S LEBANON SUMMIT ON TOP OF LEBANON MOUNTAIN. LEBANON TRAIL. MASS

AUBRY'S LEBANON SUMMIT, LEBANON TRAIL. Lebanon Trail was the local name for the early highway over Lebanon Mountain extending from Pittsfield, Massachusetts, into eastern New York. It was the route chosen when Route 20 was designated a federal highway in 1926. Judging from the number of cars in the parking lot and the bus at the service station, Aubry's Dance Pavilion was a favored stop along the road.

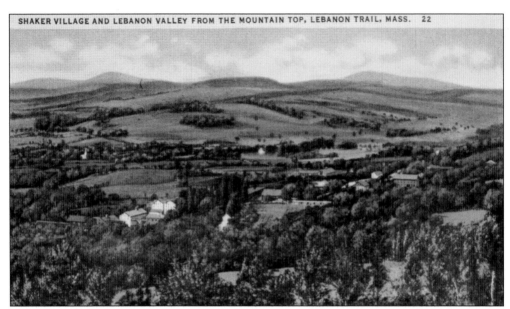

LEBANON VALLEY AND SHAKER VILLAGE FROM THE MOUNTAIN TOP, LEBANON TRAIL.
Shaker Village is the last community in Massachusetts through which Route 20 passed before
entering New York. Built on the site of the Shaker community founded in 1790, Shaker Village,
a National Historic site, is an open-air, living museum consisting of over 20 significant Shaker
buildings, including the famous stone barn. Shaker furniture, household items, crafts, and other
artifacts are on display in this museum. The peaceful view of the village and Lebanon Valley
(top photograph) is looking west toward New York. In 1878, Capt. Franklin Ellis described the
scene as "affording a view of indescribable beauty—a pleasing and harmonious combination of
mount and vale, relieved by trees, gardens, fields, and farmhouses, with an effect that delights the
eye and inspires the mind with the sublime glories of the scene." A typical Shaker community
is featured in the bottom photograph. The large residence buildings and barn are indicative of
the Shakers' communal lifestyle.

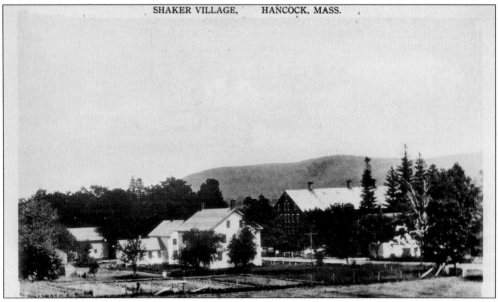

SHAKER VILLAGE, HANCOCK, MASS.

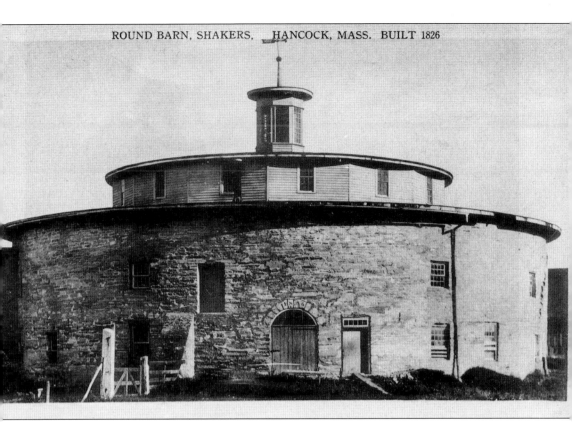

ROUND BARN, SHAKERS, HANCOCK, MASS. BUILT 1826

ROUND BARN, SHAKER VILLAGE, HANCOCK. Frequently described as one of the most unique farm buildings in the United States, this round stone barn was built in 1826. The building is 270 feet in circumference and the walls are up to 42 inches thick. The roof supports are of chestnut timbers. The barn was designed and built by the Shakers without the services of an architect. Cattle, horses, hay, and farm equipment can be housed on the two floors of the building. The original flat roof was destroyed by fire in 1864 and was replaced by a 12-sided clerestory and cupola. The 180-year-old barn has been completely restored and is a featured attraction of the Shaker Village Museum.

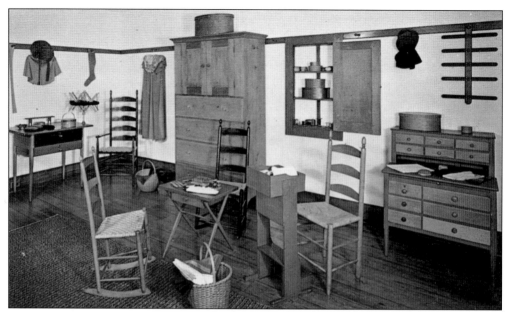

MAIN DORMITORY, SHAKER VILLAGE, HANCOCK. The Shakers were a communal living society and thus dormitories were a feature of their homes. This photograph shows a typical women's dormitory. The caption on the back of the card reads, "The Shaker sisters' famous cloaks and other garments were produced in neatly arranged workrooms like this example in the 1830 brick dwelling, the main dormitory of the village."

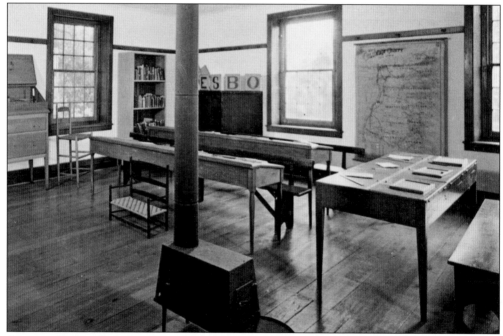

SCHOOL ROOM, SHAKER VILLAGE, HANCOCK. The caption on the back of this card describes the Shaker philosophy and system of education. It states, "Every Shaker village had its school house or school room where boys in the winter until the age of 16, and girls in the summer until the age of 14, were educated in all practical subjects."

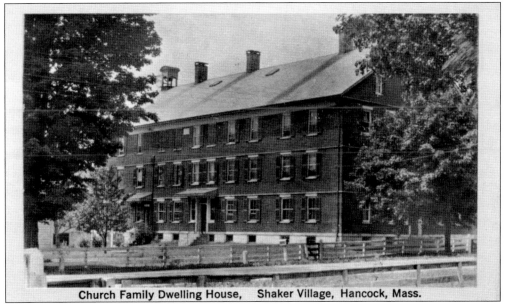

Church Family Dwelling House, Shaker Village, Hancock, Mass.

CHURCH FAMILY DWELLING HOUSE, SHAKER VILLAGE, HANCOCK. The traditional Shaker aesthetic and philosophy of "Hands to Work—Hearts to God," are reflected in this photograph. Buildings were large and utilitarian in keeping with the Shakers' communal lifestyle. They were constructed of brick, wood, and stone, all products of the land. The Shakers placed great value on daylight, and their buildings were characterized by large numbers of symmetrically placed windows.

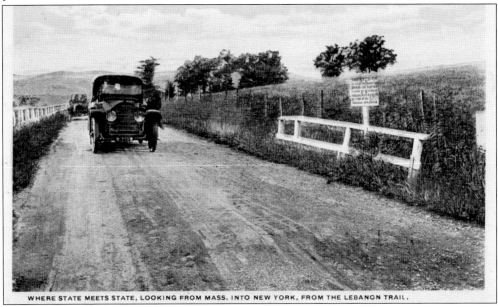

WHERE STATE MEETS STATE, LOOKING FROM MASS. INTO NEW YORK, FROM THE LEBANON TRAIL.

MASSACHUSETTS–NEW YORK STATE BORDER. Early motorists travelling on soon-to-be Route 20 in the picturesque Lebanon Valley between Massachusetts and New York received a stern warning as they crossed the border. The sign at the right reads: "TOWN OF NEW LEBANON. Do not drive more than 20 miles per hour and observe the local ordinances. Violators will be prosecuted. By order of the Town Board."

Discover Thousands of Local History Books
Featuring Millions of Vintage Images

Arcadia Publishing, the leading local history publisher in the United States, is committed to making history accessible and meaningful through publishing books that celebrate and preserve the heritage of America's people and places.

Find more books like this at
www.arcadiapublishing.com

Search for your hometown history, your old stomping grounds, and even your favorite sports team.

Consistent with our mission to preserve history on a local level, this book was printed in South Carolina on American-made paper and manufactured entirely in the United States. Products carrying the accredited Forest Stewardship Council (FSC) label are printed on 100 percent FSC-certified paper.

MADE IN THE USA